DRAWING IN
PERSPECTIVE

DRAWING IN
PERSPECTIVE

OLIVER STRIEGEL

Sterling Publishing Co., Inc. New York

Library of Congress Cataloging-in-Publication Data

Striegel, Oliver.
 [Perspektive. English]
 Drawing in perspective / by Oliver Striegel.
 p. cm.
 Includes index.
 ISBN 0-8069-0795-9
 1. Perspective. 2. Drawing—Technique. I. Title.
 NC750.S8313 1994
 742—dc20 94-17464
 CIP

English translation by Annette Englander

10 9 8 7 6 5 4 3 2 1

First paperback edition published in 1998 by
Sterling Publishing Company, Inc.
387 Park Avenue South, New York, N.Y. 10016
Originally published in Germany and © 1993 by
Ravensburger Buchverlag Otto Maier GmbH
under the title *Perspektive*
English translation © 1994 by Sterling Publishing Co., Inc.
Page 60, 61 (background), 66 © 1956 by M. C. Escher/Foundation, Baarn/Holland
Page 66 © 1954 by M. C. Escher/Foundation, Baarn/Holland
Page 60, 67 © 1960 by M. C. Escher/Foundation, Baarn/Holland
Page 64 © 1947 by M. C. Escher/Foundation, Baarn/Holland
Page 65, 66 © 1951 by M. C. Escher/Foundation, Baarn/Holland
Page 61–63 © 1993 by The Andy Warhol Foundation for the Visual Arts, Inc., New York
Distributed in Canada by Sterling Publishing
℅ Canadian Manda Group, One Atlantic Avenue, Suite 105
Toronto, Ontario, Canada M6K 3E7
Distributed in Great Britain and Europe by Cassell PLC
Wellington House, 125 Strand, London WC2R 0BB, England
Distributed in Australia by Capricorn Link (Australia) Pty Ltd.
P.O. Box 6651, Baulkham Hills, Business Centre, NSW 2153, Australia
Printed in China
All rights reserved

Sterling ISBN 0-8069-0795-9 Trade
 0-8069-4289-4 Paper

Perspective (from M.L. *perspectiva*) . . . The art or science of representing on a plane or curved surface natural objects as they appear to the eye.

—Webster's New International Dictionary of the English Language, 2nd ed., unabridged

This book is addressed to people like you and me, who are confronted every day with the task of coming up with sketches, scribbles, or drawings of objects that have to be depicted three-dimensionally.

The tips and pointers on the following pages are directed primarily towards experienced graphic artists, and those who want to become artists.

From my own experience, I know that in the three-dimensional depiction of objects, mistakes that could have been avoided sneak in again and again, or (almost worse) some things are done correctly without the artist being conscious of why they are correct.

In order to systematically use the rules and principles of figurative perspective construction, one first has to recognize them. Thus, we have come to the meaning and goal of this book: to impart the rules and laws of perspective. But this will be done not only mathematically and theoretically, or in a way that, because it is completely systematic, takes away all the fun. There are numerous books that already do that. It will be done in a way that is as illustrative and enjoyable as possible.

I want to thank all those people who helped me with the work on this book, especially my family for their support, Katrin for her scientific and culinary help, Julia for her kind criticism, Professor Rissler for his competent assistance, Professor Willberg for his typographical tips, Manfred for his patient help with CAD, Johannes for the same, Ulrike for her technical advice and achievements regarding photos, Ulli and Stefan for their support with typing, the assistant professors of the design faculty at the College of Mainz for imparting the necessary knowledge, Dr. Baatz for his trust in the project, and all those who are not mentioned for their interest.

I hope reading this book will bring you much enjoyment.

As long as three dimensionality has existed, perspective has existed. As long as human beings have existed, there have been attempts to convey spatial relations in three dimensions on two-dimensional surfaces: more precisely, to achieve the impression of depth on a plane surface. Cave drawings are the oldest known traces of three-dimensional depictions done by human hands. But it took thousands of years more before human beings, in particular painters and other artists, mastered perspective and three-dimensional illusion.

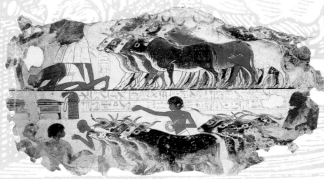

At the time of the Egyptians, about 2800 B.C., the flat, two-dimensional depiction of human beings, animals, and objects predominated, in which their symbolic content was emphasized. Out of these pictures, the first picture symbols developed, and then the first pictogramlike writing (hieroglyphics) developed. Thus, for almost 5000 years, people have communicated with pictures.

The painting above shows a fragment from the burial chamber of an unknown person from Thebes. Its subject is the sacrifice of sheep. The original can be admired in the British Museum in London. Three-dimensional depth is created here by placing the animals and people, who are all shown in profile, overlapping each other. The eyes, which are always shown from the front view, are typical of ancient Egyptian art.

In the Middle Ages, artists tried increasingly to create three-dimensional impressions in their work. This time period produced notable examples of pictorial representation that was meant to create a three-dimensional impression corresponding to reality; however, it failed to do so. A kind of space surrealism was created. It is clear that in the Middle Ages, people did not know how to draw in perspective. Nevertheless, these pieces of art, which are very valuable and fine, do not lack a special charm.

At that time, painting, in the form of book illumination, began to develop rapidly. One of the latest and best-known examples is a book of hours, *Les très riches heures du duc de Berry* (1416). An illustration from it is shown in the picture below.

Regarding the "free" usage of perspective, the construction of the stairways in the picture at the bottom right of this page is striking. The

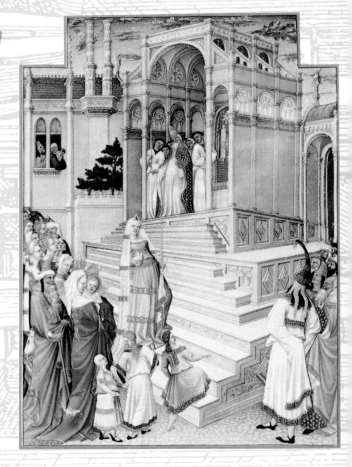

principle of decreasing the spacing between parallel lines as they recede into space was correctly recognized.

The Renaissance brought the dawn of a new era. It was the rebirth of knowledge from ancient Greece and Rome. In new buildings,

In addition to his well-known pieces of art, Albrecht Dürer (1471–1528) wrote numerous theoretical papers. His handbook, *Instruction of Measurement* (1525), deals with perspective. In several woodcuts, he shows how a draftsman can make three-dimensional construction easier

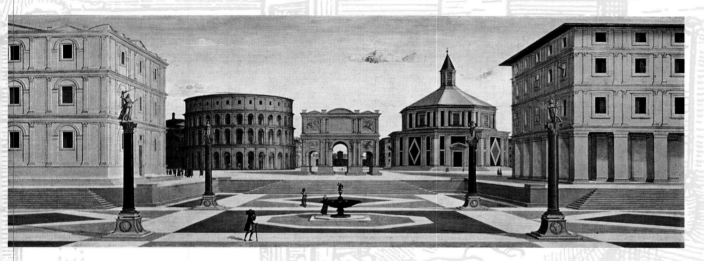

sculptures, and the visual arts, the classical world was invoked. But the understanding of perspective was a new accomplishment of the Renaissance.

In 1435, only a few years after the hour book of the duc de Berry, the first theoretical treatise about constructing perspective was written. The work was titled *De pictura* and its author was the Italian architect Leone Battista Alberti (1404–1472).

Construction using central perspective was used in a majority of the depictions at the time of the Renaissance. In depictions of groups of people, the main figure could be made to stand out. In depicting architecture (both real and fantastic), the newly acquired knowledge of central perspective could be demonstrated very effectively.

An example of an architectural drawing done in perspective is shown in the picture above. This work by the Italian Luciano Laurana (1420–1479), which was created between 1450 and 1475, is today in the Walters Art Gallery in Baltimore.

for himself.

In the illustration below, *The Draftsman with the Lute,* exhibited in Kunsthalle Bremen, Dürer demonstrates the projection of an object onto a picture plane with the help of a string, which depicts the line of sight. This way, the instrument is built up dot by dot, just as we would do it today.

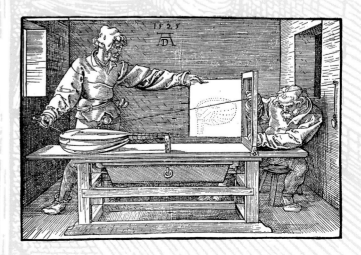

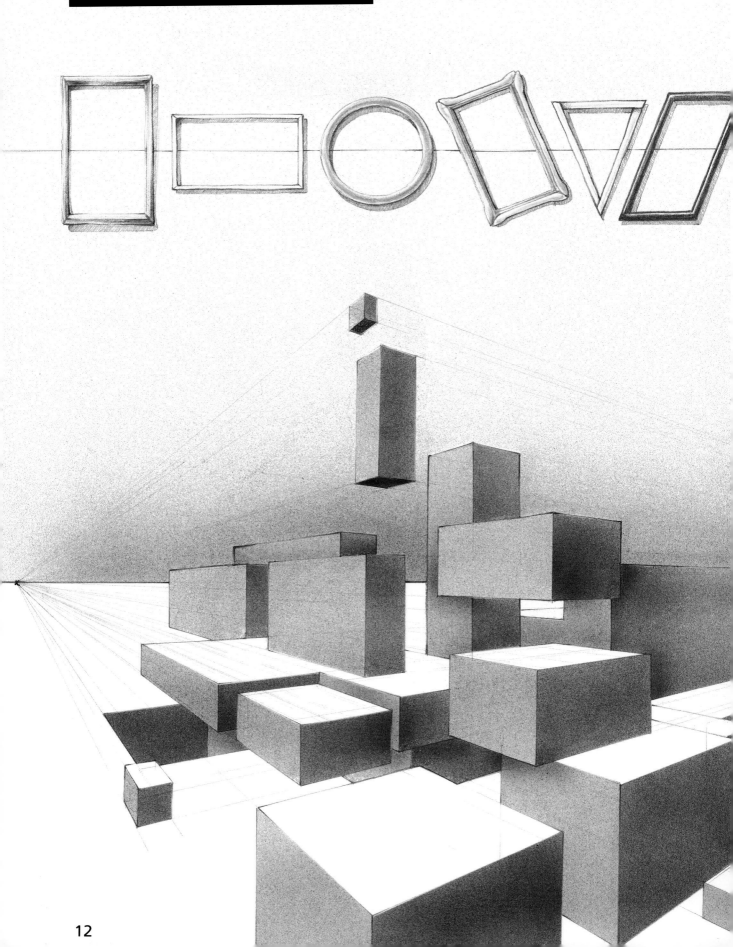

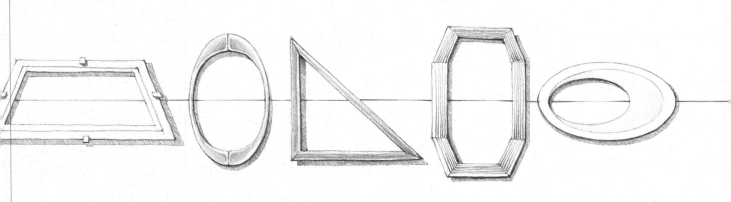

The shape of the picture plane is an important factor in the creation of a picture, whether or not the picture is being constructed in perspective.

In addition to the classical formats of the rectangle (vertical or horizontal) and the square, there are numerous other variations, as the row of frames above shows.

The horizon line always lies horizontally in the picture. If this is not the case, then the picture isn't hanging straight.

The correctly chosen section of what you see is the determining factor for the tension of the picture. In order to find the right section, please trace out the template of the viewfinder on page 77, cut out the shapes inside the frames, and paint the template. Then hold it between the picture on the left and your right eye. (Your left eye should be closed.) When you have found the correct section for your drawing, trace it out. Afterwards, you can do with it whatever you like; for example, you can glue it into a frame.

Another essential factor is the position of the horizon line in the picture. The horizon line is the artist's eye level when the spectator's line of sight is parallel to the ground. The intended effect of the picture can be dramatically enhanced or weakened by the choice of horizon line.

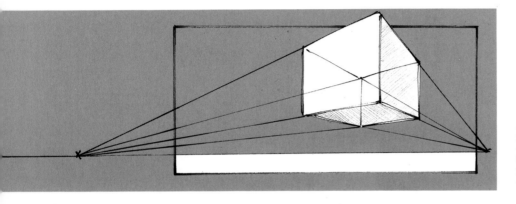

Here, the horizon lies relatively low in the picture. The object is seen from a low visual angle; therefore, this view is called the *worm's eye view*.

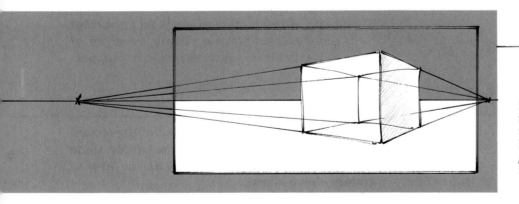

In this picture, the horizon is in the middle of the picture and divides it horizontally into two halves. We call this view *normal perspective*. It corresponds to our usual eye level.

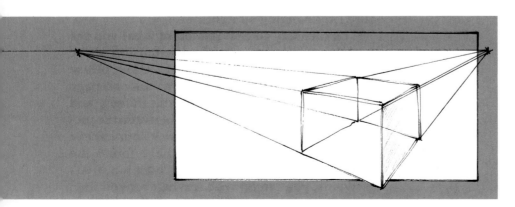

The third possibility is shown here. The horizon is relatively high up in the picture, which results in the visual angle of the viewer being raised. This view is called the *bird's-eye view*.

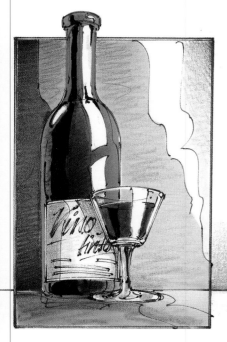

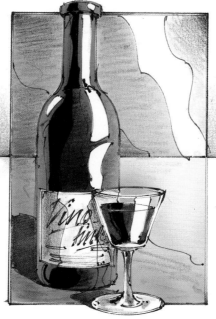

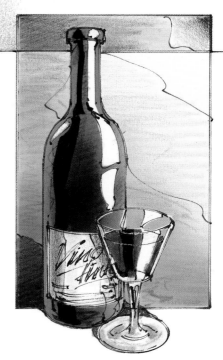

The three sketches on this page are based on the models on the left-hand page. This picture is laid out in the worm's-eye view. The bottle and the glass seem to be elevated, detached, almost arrogant.

The eye level of the artist is always at the level of the horizon line. Thus, the two objects look down on us here.

The same bottle and glass are drawn in normal perspective. A neutral view of the objects is shown. This has the effect of being restrained, undetermined, and passive.

The objects are drawn from the bird's-eye view. In this case, the viewer stands above the objects. The bottle and glass gain the psychological effect of appearing humble and inviting.

HH

The third aspect to which one has to pay attention is the distance between the individual vanishing points.

All parallel lines come together at one vanishing point. For an object to be drawn in perspective, at least one vanishing point is necessary (see One-Point Perspective). In two- and three-point perspective, there are more vanishing points.

When the distance between the vanishing points is changed, the dimensions of the objects depicted and the impressions they give also change.

The relations between vanishing points can be distorted or manipulated to achieve theatrical effects; for example, a cigarette package can seem as large as the Empire State Building. In order to illustrate these effects, I invited a guest from the world of comic strips to help me.

The 50-mm Effect. In our case, this is the right solution. (The dog is visibly happy.)

Objects of medium size, for example, the doghouse, can be depicted realistically this way.

If we took a photograph like this, the normal lens would have a 50-mm focal length.

VP1

VP1

The 200-mm Effect. The vanishing points VP1 and VP2 are far apart. The object in red does not seem to be very large. The depiction corresponds to a snapshot taken with a telephoto lens.

Smaller objects, such as a food bowl, can be constructed in this way so that they look realistic.

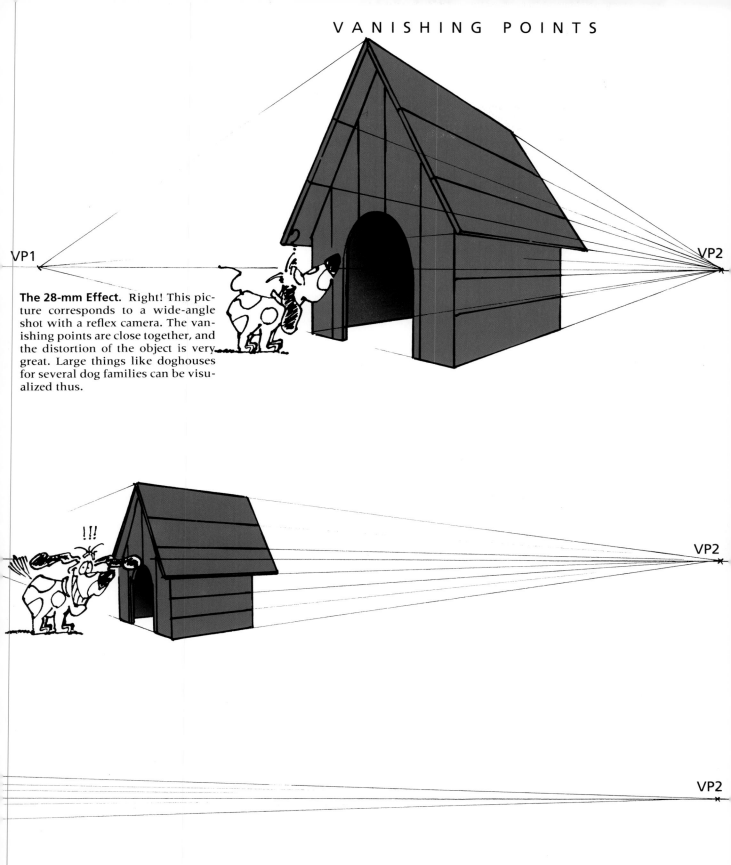

VP1

VP2

The 28-mm Effect. Right! This picture corresponds to a wide-angle shot with a reflex camera. The vanishing points are close together, and the distortion of the object is very great. Large things like doghouses for several dog families can be visualized thus.

VP2

VP2

With the shape of the picture plane, the position of the horizon, and the distance between the vanishing points clarified, the object construction can follow. But first, the artist's station point has to be determined.

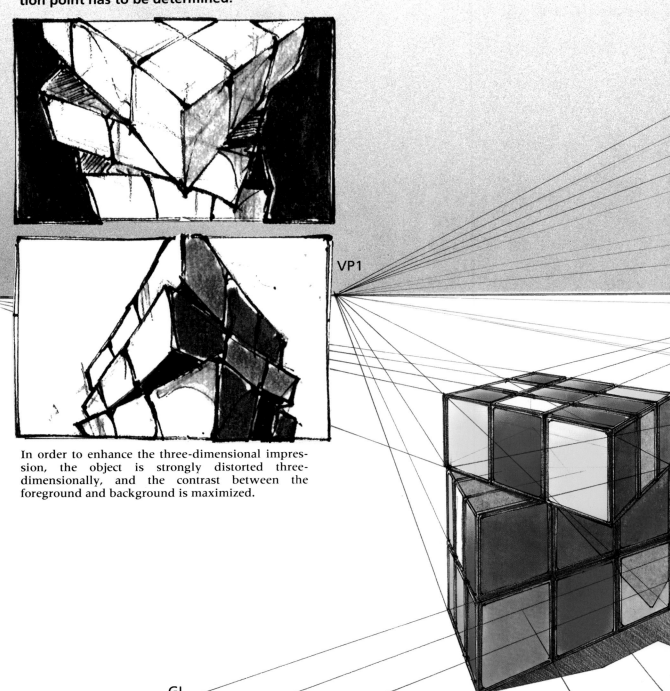

In order to enhance the three-dimensional impression, the object is strongly distorted three-dimensionally, and the contrast between the foreground and background is maximized.

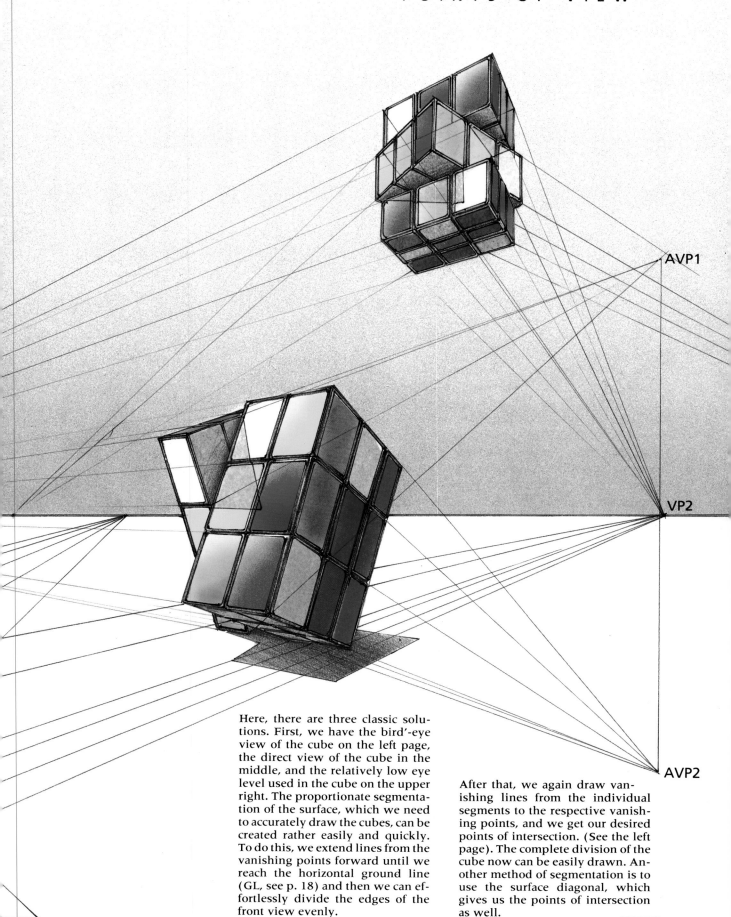

AVP1

VP2

AVP2

Here, there are three classic solutions. First, we have the bird'-eye view of the cube on the left page, the direct view of the cube in the middle, and the relatively low eye level used in the cube on the upper right. The proportionate segmentation of the surface, which we need to accurately draw the cubes, can be created rather easily and quickly. To do this, we extend lines from the vanishing points forward until we reach the horizontal ground line (GL, see p. 18) and then we can effortlessly divide the edges of the front view evenly.

After that, we again draw vanishing lines from the individual segments to the respective vanishing points, and we get our desired points of intersection. (See the left page). The complete division of the cube now can be easily drawn. Another method of segmentation is to use the surface diagonal, which gives us the points of intersection as well.

Besides "genuine" perspective, there are a number of geometric constructions that convey a more or less three-dimensional impression. These are the isometric and axonometric projections. They are used primarily in the work of architects.

In isometric and axonometric depictions of objects, all parallels remain parallel. In this type of construction, there are no vanishing points. This is the main difference between these and actual three-dimensional reproductions.

Another important factor distinguishing them from "genuine" perspective is the partial undistorted reproduction of edges, surfaces, and angles. The following examples will serve as illustration of this. To demonstrate these systems of perspective, I will use a little dropper bottle of airbrush-color, which you might buy in an art supply store. To the left below, the side view can be seen, next to the overhead view. The outline of the object on the ground surface (the footprint) is a square.

Military Perspective. Here, the starting point is the undistorted footprint of the object, in our case, the square. It is turned until an angle combination of 30°/60° is created on the ground line (see drawing below). Other combinations are possible. The height and upright edges are drawn without distortion. There is the possibility of shortening the height a certain percentage.

Finally, the bottle top is placed on top. Again, start with the footprint of the object, in this case, a circle.

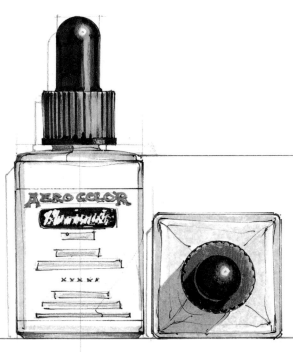

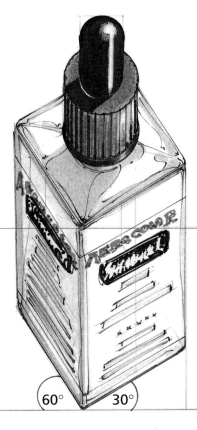

GL

Cavalier Perspective. In this construction, we start from an undistorted viewing surface of the object. The receding edges of the object are drawn at the corner points of the surface at an angle of 45°, starting from the GL (ground line). In order to enhance the three-dimensional impression, the receding edges are shortened a certain amount, e.g., to half the length of the front line. Again, all object edges that are actually parallel are drawn parallel. The front surface and the back surface of the object are parallel and of equal length. The base surface of the bottle top becomes an ellipse.

Isometric Perspective. In the isometric representation, we start from an undistorted vertical edge. The receding edges are added in their original lengths at angles of 30° and 30° (see example below) or 15° and 45°, measuring from the ground line (GL). This results in an interior angle of 120° for the object, measured from the ground line (180° − 60°). The remaining edges of the object are drawn parallel to the ones already laid down, until the object seems to be closed up. The circular base of the bottle top appears as an ellipse.

Dimetric Perspective. Dimetric perspective, like cavalier perspective, starts from a surface of the object. But this one is distorted slightly, drawn at an angle of about 7° from the ground line (see illustration below).

The receding edges are all shortened the same common percent to achieve a three-dimensional effect. They proceed from the ground line upwards at an angle of about 42°.

The edges and surfaces of the object remain parallel, and the circular forms appear as ellipses.

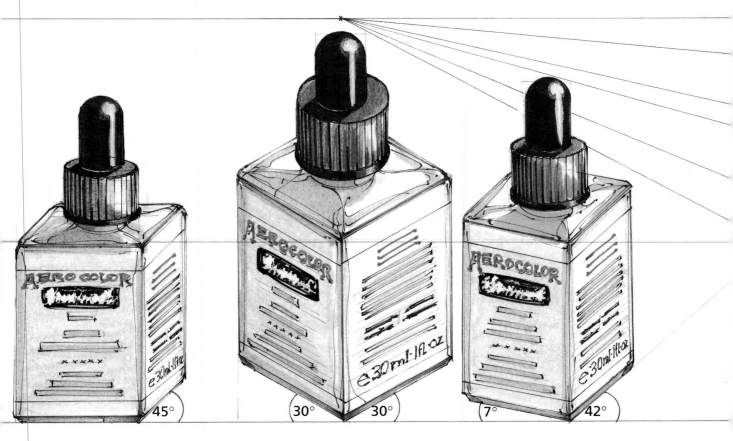

Central Perspective. Central perspective, or one-point perspective, is the simplest kind of ''genuine'' perspective construction. Rectangular objects are placed so their front sides are parallel to the picture plane. The depth of the object is perpendicular to the picture plane. All parallel receding edges run towards a common vanishing point, called the central vanishing point. The viewer looks towards this central vanishing point with a straight view. (More about that in the following chapter.)

Two-Point Perspective. Two-point perspective construction is the kind that is used most frequently. In this construction, only the vertical lines remain parallel. (In three-point perspective, the verticals also end in a vanishing point; see the chapter on three-point perspective for more information.)

All receding edges appear shortened and end in a common vanishing point, as long as they are parallel on the original object.

In addition, all horizontal receding edges end in vanishing points directly on the horizon line. All non-horizontal edges, on the other hand, end above or below the horizon. (More about that in the chapter on two-point perspective.)

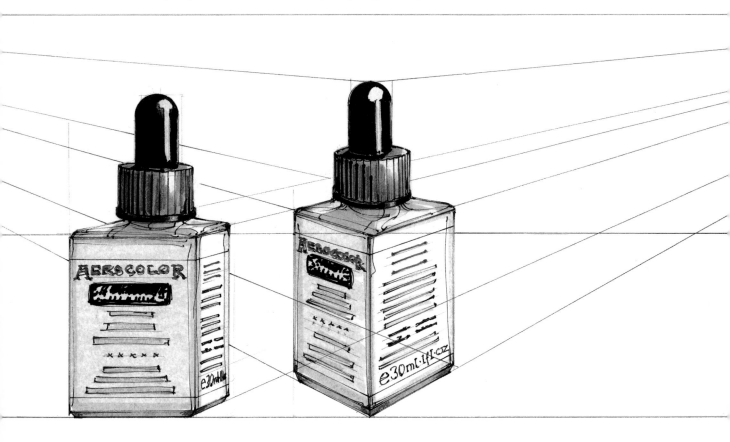

ABBREVIATIONS

In the following chapters, we will use some abbreviations. On this page, they are listed and defined.

PP The picture plane (shape is variable)

PPO The picture plane in the overhead view (the canvas or the draw paper is viewed from above)

HH The horizon line (as usual, horizontal)

VP1, VP2, VP3 Vanishing points 1, 2, and 3

CVP The central vanishing point, the intersection of the perpendicular l from S with the HH

S The station point (the location of the viewer's eyes)

DVP The diagonal vanishing point, the vanishing point of the diagona one-point (central) perspective

h This is the height (of an object or a distance)

h′ The projection of h

h″ The projection of h′

a, b, c The corner points of the object

a′, b′, c′ The projection of a, b, c, . . .

a″, b″, c″ The projection of a′, b′, c′ . . .

GL The ground line (usually the lower edge of the PP)

GP Ground plane, the horizontal reference plane from which vertical m surements are taken

A The picture area (the surface between the GL and HH)

abcd The outline (or footprint) of the object on the ground surface (e.g square)

LS The line of sight from the station point

VL The vanishing point of the light source (L)

VS The vanishing point of the shadow

L The light source

α Angle of incidence of a light source to the horizon.

FP1, FP2, FP3 The foot points (the perpendicular projections on the GP of points above and/or below the GP

AVP The accidental vanishing point (the vanishing point for inclined planes such as roof inclines, opened lids, and everything that is not parallel to the ground plane)

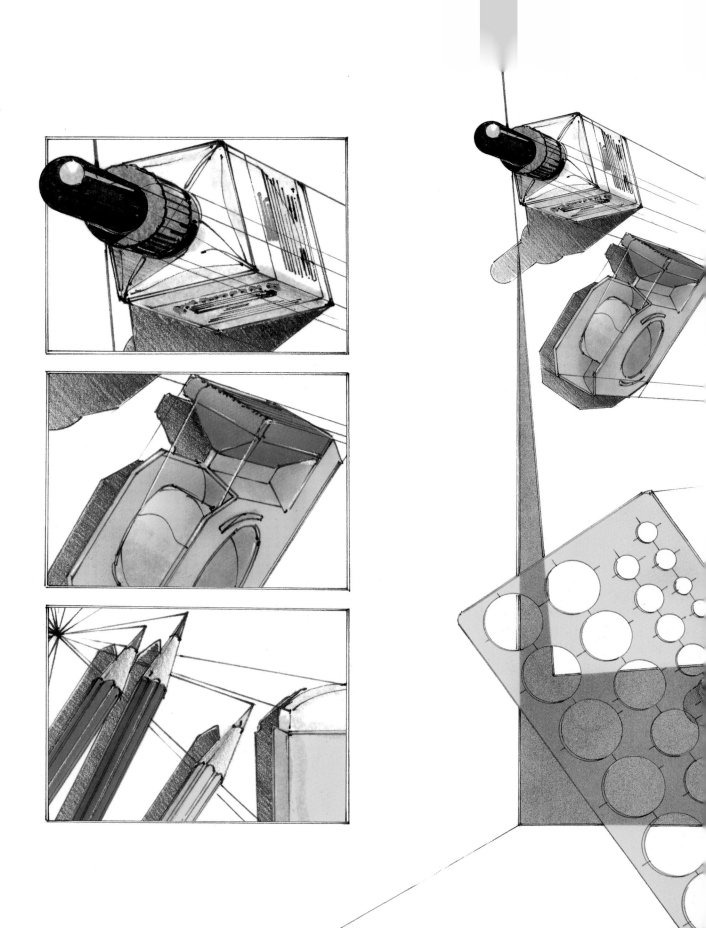

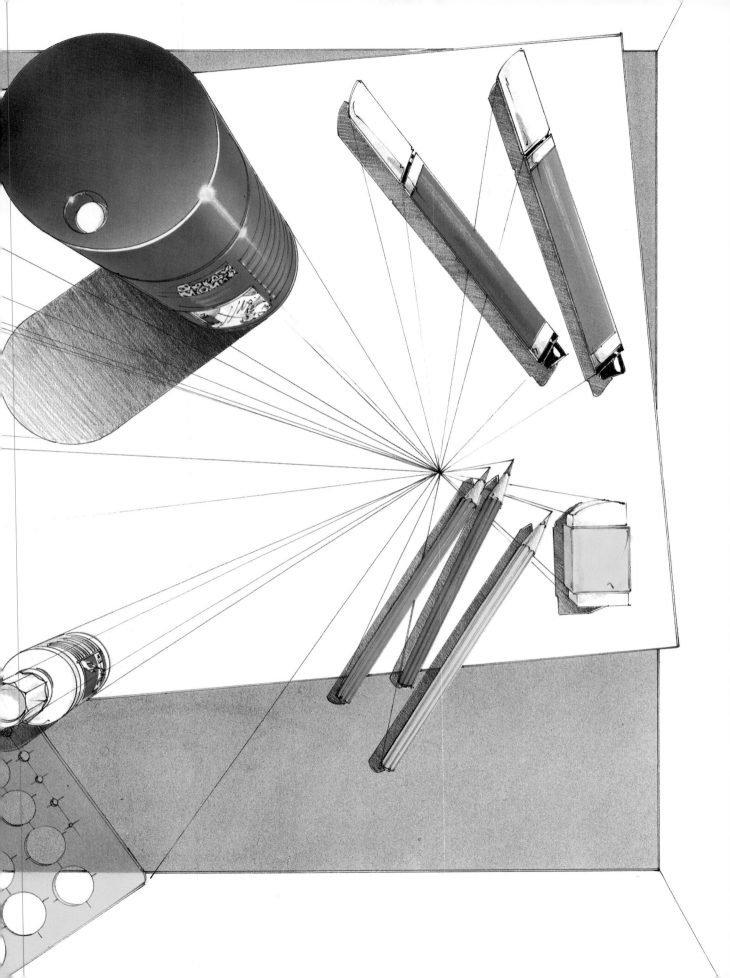

As already mentioned, one-point perspective, or central perspective, is the simplest kind of perspective construction.

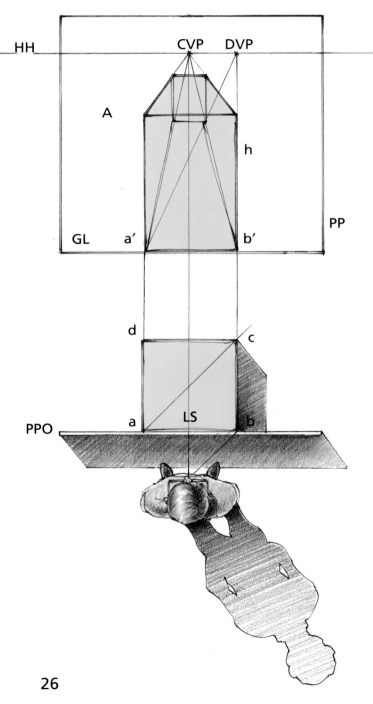

In the picture on the lower left, the three variables that are needed for construction of perspective are shown in the overhead view: the onlooker with glasses, the picture plane (PPO), and the object, shown in bright yellow.

When we fold the scenery back 90° (top drawing), we see the picture plane (PP) in the view and, in it, the construction of the beautiful object, as the onlooker sees it.

The picture area (A) appears in a ratio of 1:1; h does as well, since they lie directly on the PPO. If we assume that S, the station point, lies on the nose of the onlooker, then the LS appears perpendicular to HH, the horizon line. All the receding edges of the rectangular solid come together at CVP (where else?).

DVP, the diagonal vanishing point, is constructed as follows: First draw a line from the projection of the edge of the object (b') on the ground line (GL) up, parallel with the line of sight (LS), until it hits the horizon line (HH). Then draw a second line from a' (the projection of a on the ground line) to meet the horizon line and the line just drawn. Where all 3 intersect is the DVP, the diagonal vanishing point.

The point of intersection of the straight lines a'DVP and b'CVP determines the projection of the rear surface.

As we will see, in order to avoid extreme distortions in the projection, it is advisable to restrict the cone of vision around the line of sight to no more than 60°. Well, quite simple actually, isn't it?

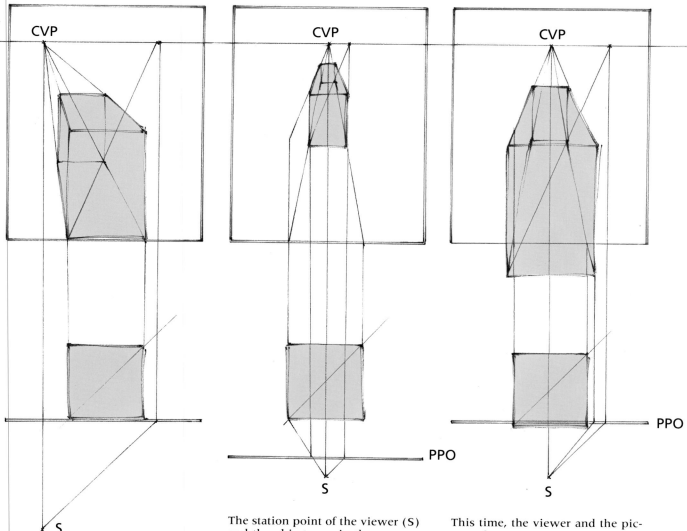

If at least one of the variables is altered, the picture also is changed. Here, I changed the station point of the viewer (S). The projection thus is seen more from the left. The front surface of the object remains the same.

The station point of the viewer (S) and the object remain the same as in the drawing on the opposite page. Only PPO was placed closer to the viewer. Because of this, the projection is further back from the ground line (GL) and appears smaller in the picture. The point of view does not change.

This time, the viewer and the picture plane remain constant in their position. The object moves forward through the PPO towards the station point of the artist. The projection of the cube changes in size and even breaks the frame of the picture plane. The point of view (S) remains the same.

In order to make the construction of the central perspective a little bit easier, it is possible to construct a uniform grid beforehand, into which the object or objects are placed.

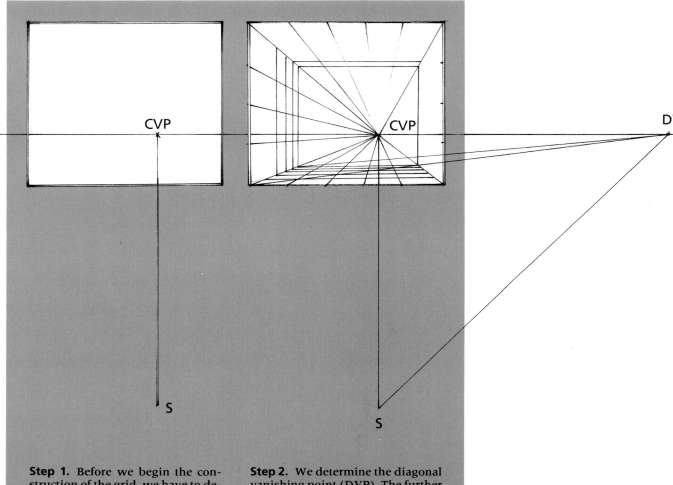

Step 1. Before we begin the construction of the grid, we have to determine the station point (S), the horizon line (HH), and the size and placement of the picture plane (PP). The central vanishing point (CVP) then is drawn in perpendicularly from the station point to the horizon line.

Step 2. We determine the diagonal vanishing point (DVP). The further the DVP moves from the CVP (the central vanishing point), the closer the grid lines are to each other. The outer edges of the picture plane are divided evenly to make the grid. The grid points are then connected with the CVP. The distance from S to CVP determines the distance from CVP to DVP (they are the same).

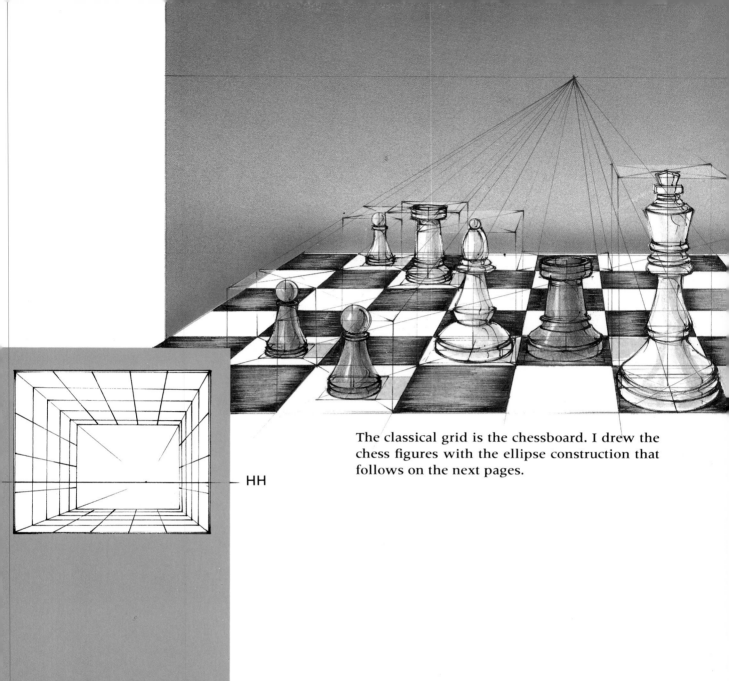

HH

The classical grid is the chessboard. I drew the chess figures with the ellipse construction that follows on the next pages.

Step 3. A corner point that is at the opposite side of the PP from the CVP is connected with the DVP by a line. The points of intersection of the connecting line just drawn with the grid lines give us the points for the horizontal lines which finally divide the space into receding rect-angles. Finished!

When we see an inclined circular surface, i.e., a circular surface that is not perpendicular to the line of sight (a straight line from S to CVP), the circle appears as an ellipse.

In the construction of the ellipse, a square is drawn first, to make things easier. Into this, we draw a nice ellipse.

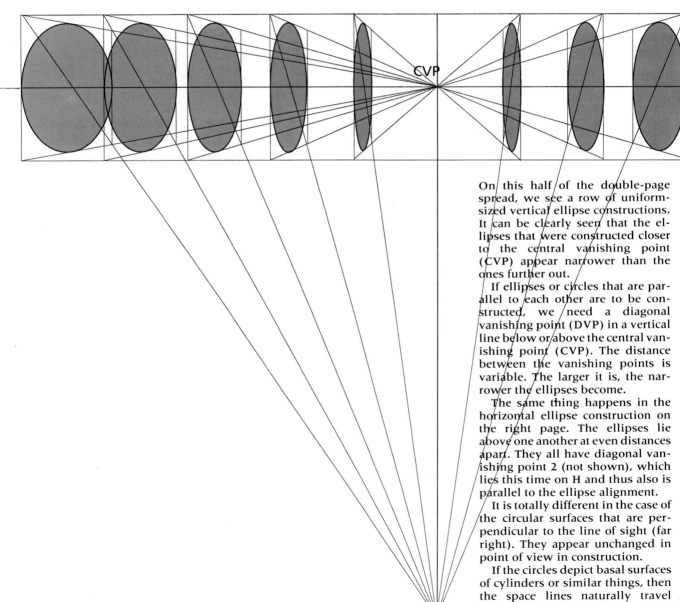

On this half of the double-page spread, we see a row of uniform-sized vertical ellipse constructions. It can be clearly seen that the ellipses that were constructed closer to the central vanishing point (CVP) appear narrower than the ones further out.

If ellipses or circles that are parallel to each other are to be constructed, we need a diagonal vanishing point (DVP) in a vertical line below or above the central vanishing point (CVP). The distance between the vanishing points is variable. The larger it is, the narrower the ellipses become.

The same thing happens in the horizontal ellipse construction on the right page. The ellipses lie above one another at even distances apart. They all have diagonal vanishing point 2 (not shown), which lies this time on H and thus also is parallel to the ellipse alignment.

It is totally different in the case of the circular surfaces that are perpendicular to the line of sight (far right). They appear unchanged in point of view in construction.

If the circles depict basal surfaces of cylinders or similar things, then the space lines naturally travel again to CVP 3.

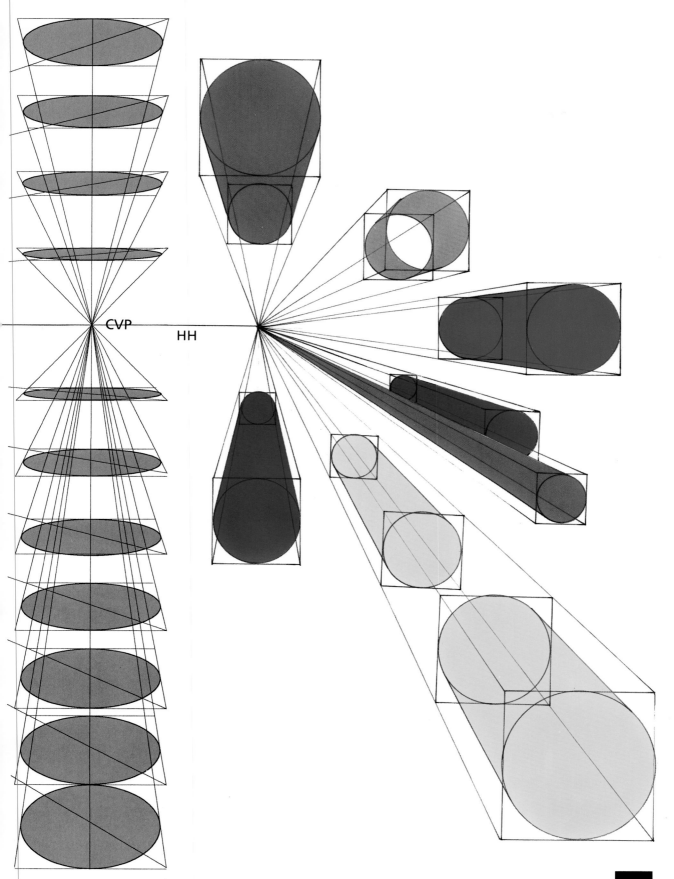

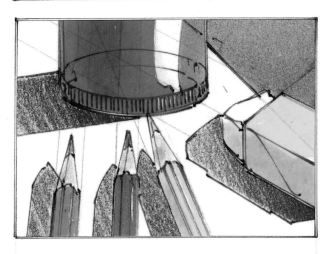

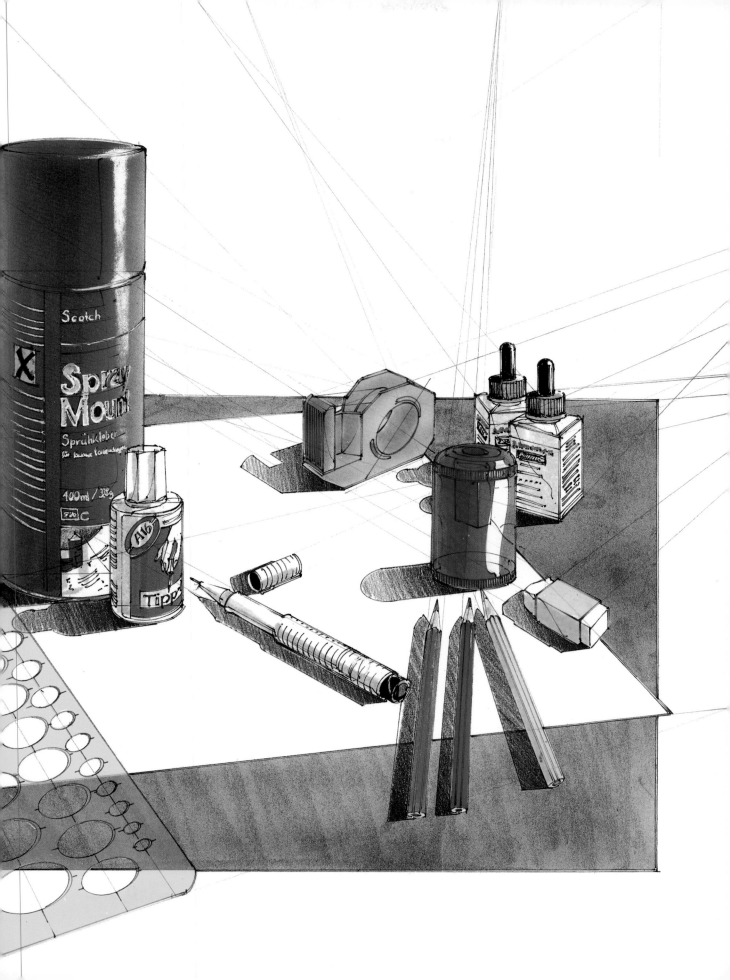

The following object construction using two-point perspective is not much more difficult than the construction using central perspective (one-point perspective). Most objects can be depicted three-dimensionally with two vanishing points.

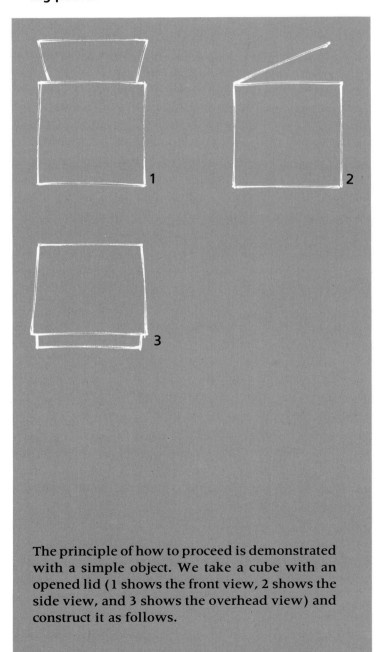

The principle of how to proceed is demonstrated with a simple object. We take a cube with an opened lid (1 shows the front view, 2 shows the side view, and 3 shows the overhead view) and construct it as follows.

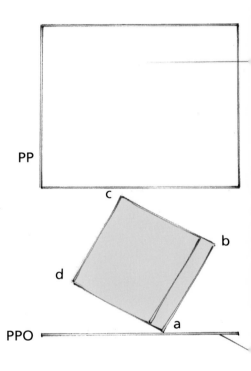

Step 1. One moment! Before we begin with the construction, we again need our usual three things: S (the station point), PPO (the picture plane shown from overhead), and the object (in yellow). Remember that the PPO is usually between S and the object.

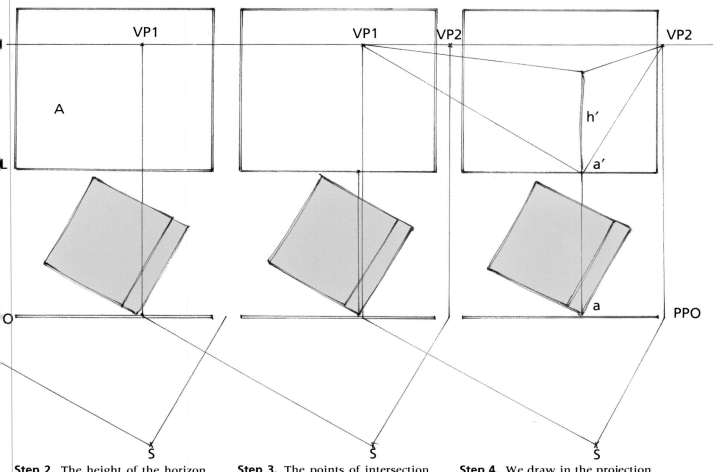

Step 2. The height of the horizon line (HH) on the picture plane has been determined, and the work can begin. First, we concentrate on the construction of the vanishing points, VP1 and VP2. To do this, parallels to the base sides of the object are drawn from S, until they intersect the level of the PPO.

Step 3. The points of intersection are projected onto HH (the horizon line) and they result in the two desired vanishing points, VP1 and VP2. The corner point a' of the object lies in our example directly at the PPO (picture plane in overhead view), therefore the h' from a has to be reproduced in the ratio of 1:1 on the picture plane. Beforehand, a is projected up vertically from the GL (ground line).

Step 4. We draw in the projection of the original object height, h', from a'. All edges and surfaces directly on the PPO appear as a rule at a ratio of 1:1 on the PP.

Let's continue. From the two end points of h', we draw vanishing lines to VP1 and VP2.

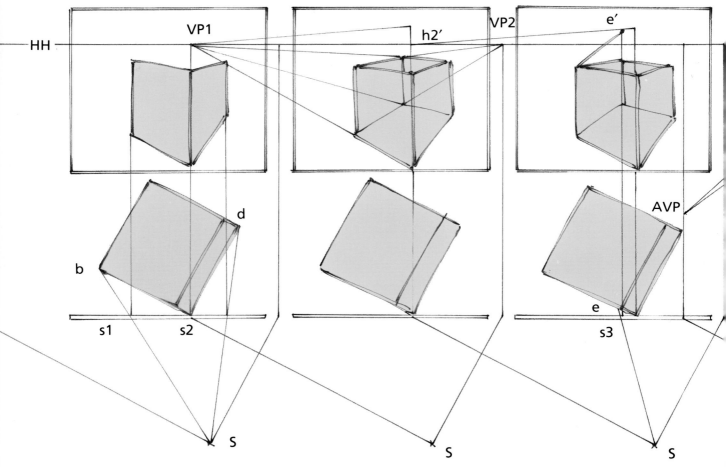

Step 5. So far so good. Now we draw the connecting lines between the two endpoints b and d and S. From the points of intersection s1 and s2 on PPO, perpendiculars are projected onto the picture plane, until they intersect the vanishing point lines. Do the two visible object surfaces in yellow appear distorted? Yes, they do.

Step 6. The newly drawn corner points are connected with VP1 and VP2. This time, the final corner points result. The construction of the yellow cube normally would be finished at this point. Not in our case. Next, the opened lid is constructed. For this, we draw h2' true to scale onto it and connect the end point with VP1.

Step 7. From S we sight a line to point e. This gives us a further point of intersection on PPO. It is called s3. From s3, we draw a vertical on PP, until our point of intersection, e', is located. Good. The front edge of the lid is completed. To finalize it, we draw a vanishing line from e' to VP2 as shown in the next diagram.

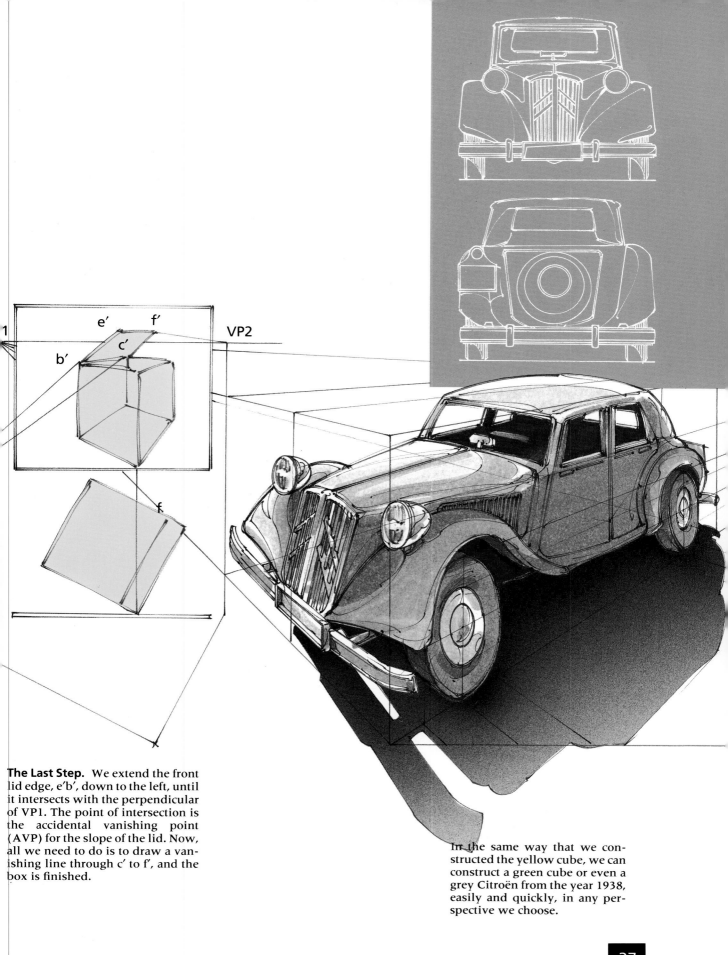

The Last Step. We extend the front lid edge, e'b', down to the left, until it intersects with the perpendicular of VP1. The point of intersection is the accidental vanishing point (AVP) for the slope of the lid. Now, all we need to do is to draw a vanishing line through c' to f', and the box is finished.

In the same way that we constructed the yellow cube, we can construct a green cube or even a grey Citroën from the year 1938, easily and quickly, in any perspective we choose.

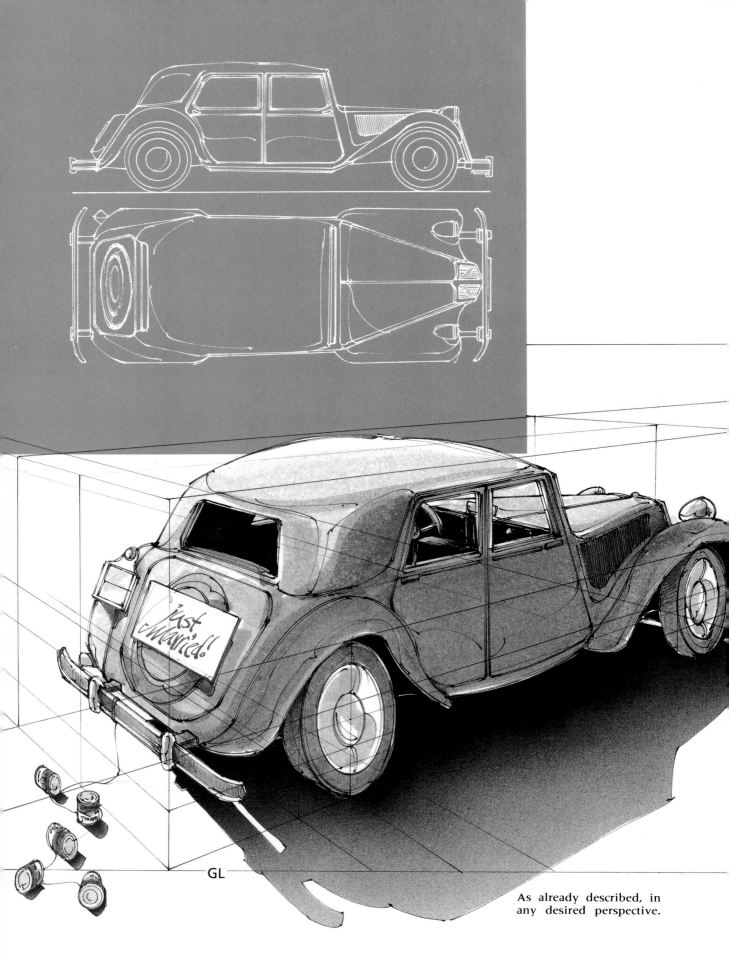

"just Married!"

GL

As already described, in any desired perspective.

38

Below we state the most important points to be observed in object construction by means of perspective. (Some haven't been covered yet, but will be in the pages to come.)

VP2

- All lines that are parallel on an object end in one vanishing point, with the exception of the parallels to the horizon line.
- All horizontal lines have their vanishing points on the horizon.
- All diagonals have their accidental vanishing points above or below the horizon line.
- All vertical lines in one-point and 2-point perspective drawing are parallel to each other. Exception: overhead construction in one-point perspective.
- In three-point perspective, all vertical lines run in towards one vanishing point.
- The horizon line always lies horizontal on the picture plane.
- The eye level of the viewer is the same as the level of the horizon line.
- The shorter the distance between the vanishing points, the more distorted the picture appears to be.
- The larger the visual angle (cone of vision) becomes, the stronger distortion at the edges be-comes (this can be seen in photographs).
- All edges and surfaces that lie in the picture plane appear on a scale of 1:1.
- All edges and surfaces in front of the picture plane appear larger.
- And vice versa.
- The higher the sun or the sun's projection is above or below the horizon, the shorter is the shadow.
- In back lighting construction, the sun's vanishing point appears above the horizon.
- In front lighting construction, the sun's vanishing point appears below the horizon.
- In direct side lighting, there is no shadow end-point.
- The shadow's vanishing point is always vertical, below or above the sun's vanishing point, and is on the horizon.
- The edges of mirror images usually end at the object's vanishing points.
- Behind the horizon it continues. . . .

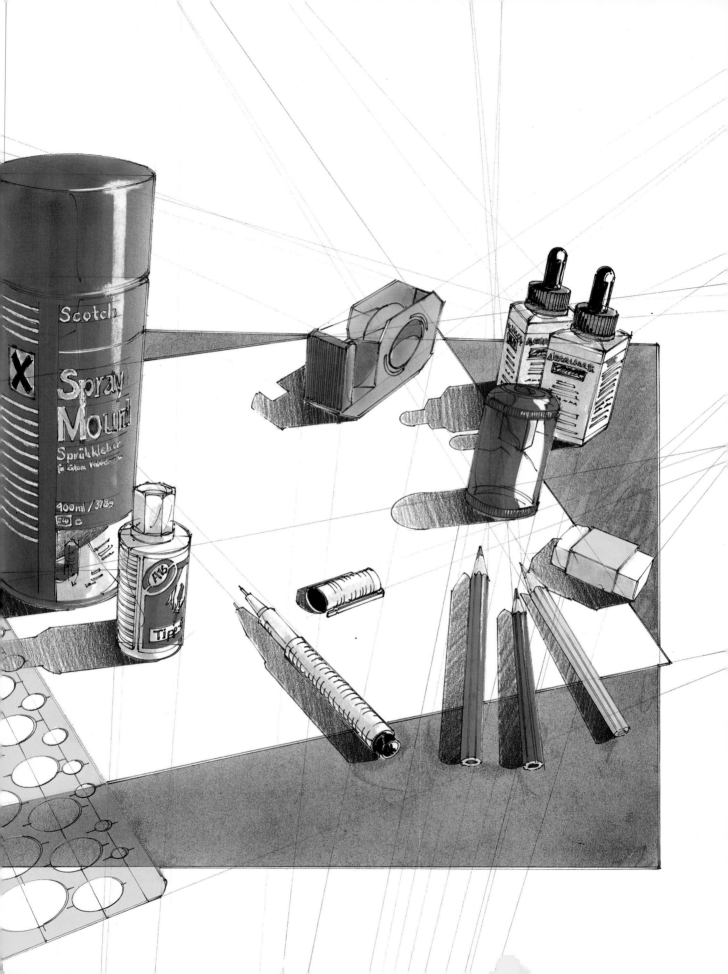

. . . it unfolds in all its splendor in front of us. The depiction of objects in true three-point perspective is the peak of three-dimensional representation. No line appears parallel to another any more.

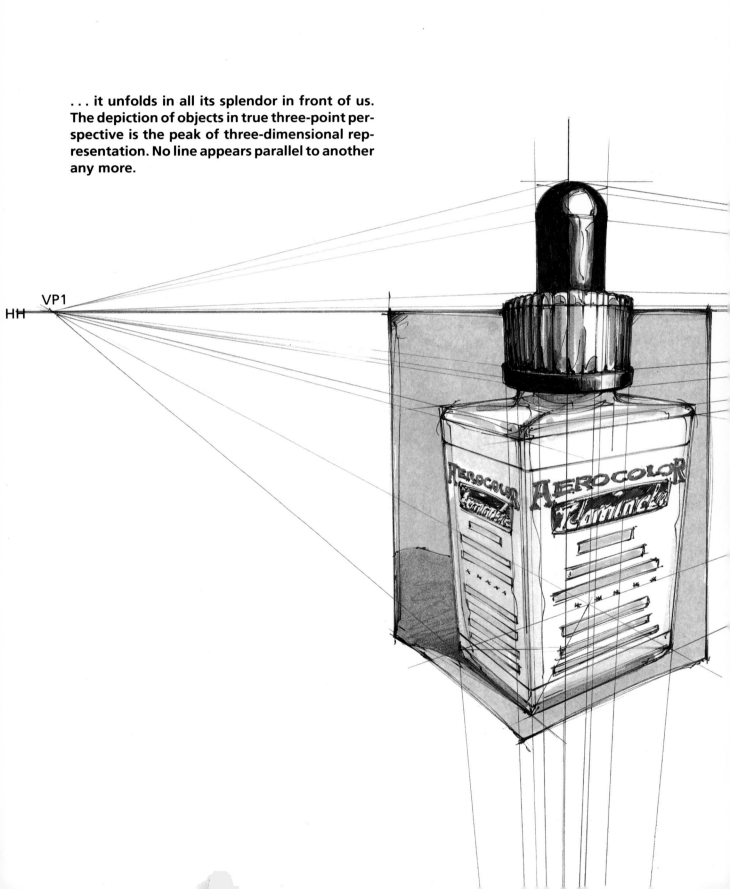

The construction of horizontals is the same as for two-point perspective.

What is new is the third vanishing point (VP3) for the verticals. The further away from the horizon it is placed, the less vertical distortion of the object there is. In our example above, VP3 is still relatively close to the horizon line. The previously discussed 28-mm effect is evident. When strong distortion is not desired, there are ways of taking remedial measures. Either we simply draw the object smaller and leave the vanishing points in their positions, or we take three paper strips and glue them to the left, to the right, and to the bottom of our paper. After that, we can widen the horizon and place VP1 and VP2 further to the outside. We place VP3 39 inches (1 m) further down.

The further above the overhead view is in the construction, the smaller the distance between VP3 and HH becomes. VP3 always lies on the perpendicular of CVP. (When they are identical, the result is like pages 24–25.)

There are two more important points to be noted:

All vertical edges that lie below HH have a vanishing point below HH. This also holds true the other way around. Strictly speaking, the rubber part on the screw-on top of the bottle shown above should taper off upwards to a VP4. The perpendicular from VP3 to the horizon give us the central vanishing point. Or the other way around. The further away from the CVP the objects are placed, the greater the distortion becomes, until, at some point, the construction does not look good anymore. In order to avoid that, the objects should be constructed closer together, or VP3 should be placed further down.

VP3

VP3

Before we get to the construction of our object in three-point perspective, we will take a small excursion.

The example below shows a little bottle, so we can see how an evenly divided, circular surface looks in perspective construction and how it is created.

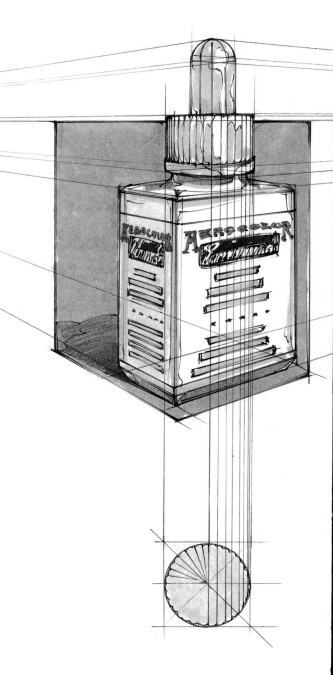

VP1

HH

In the previous chapter we discussed how simple surfaces like squares or circles are projected from the overhead view onto the three-dimensional view. The laws that have to be observed to do that are, of course, also valid for the projection of more complex forms—for example, the screw-on top at the right.

From the outer edges and from each individual division of the base surface, we draw parallel vertical projection lines onto the picture plane. The ellipses are constructed as described earlier. The corrugation of the screw-on top is drawn in. We can see that the corrugations in the three-dimensional depiction seem to run together towards the outer edges of the top.

The two smaller pictures in black and white on the opposite page show two free constructions of ball bearings. The inner ball ring was divided in the same way as the screw-on top.

In order to enhance the three-dimensional effect, I defined shadows and backgrounds. (More about those in the following chapter.) But before that, you'll find the promised presentation of three-point perspective. For that, simply open up this folded page and . . .

open
gently
and fold
pages 42
and 43
down . . .

VP2

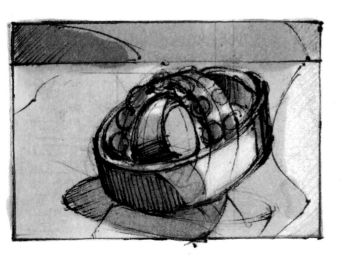

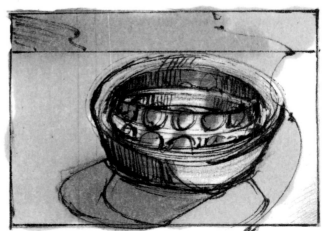

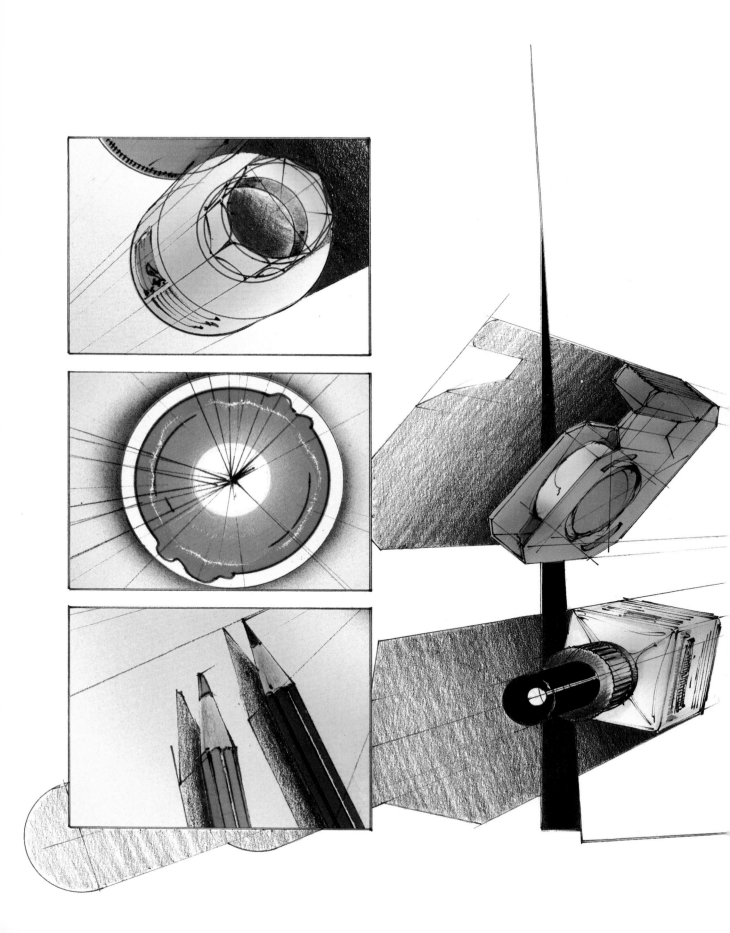

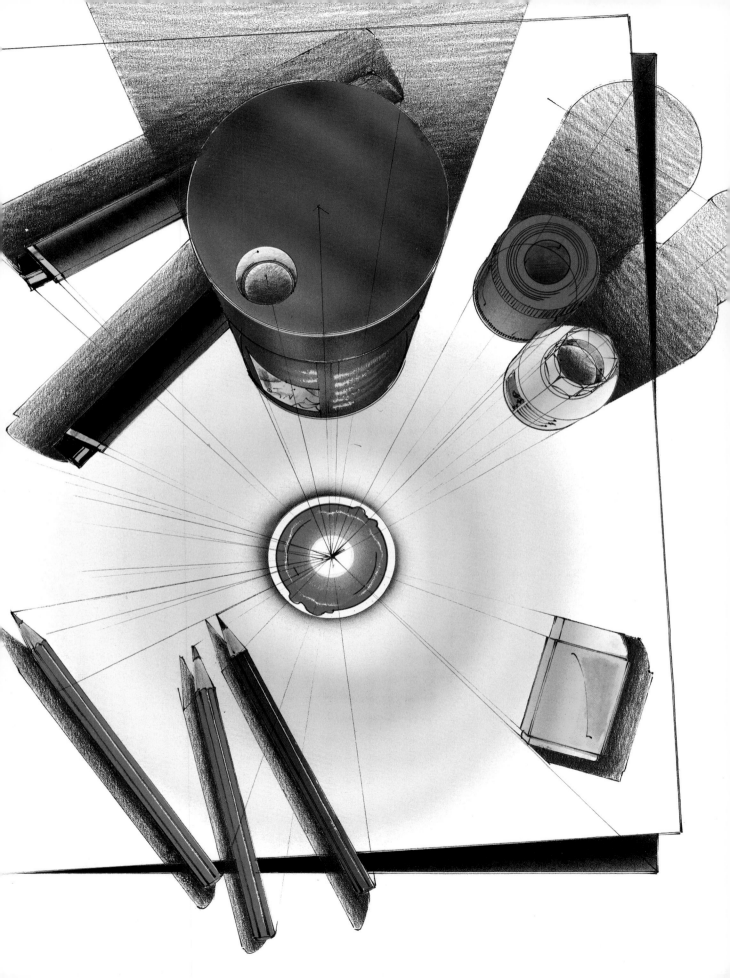

It is light that makes things visible in the first place. And where there is light, there is also shadow. We do not want to deal here with the construction of shadow on individual objects or with the shadows one object makes on another. But if you want to understand the shadow of an object on the picture plane, you have come to the right place.

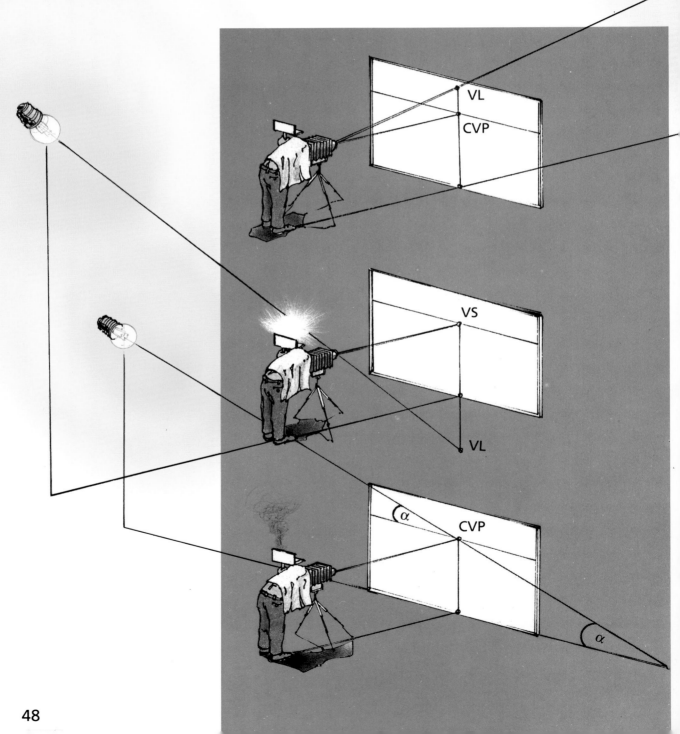

Back Lighting. The light source (100 watts) is located behind the picture plane and above the horizon. A projection ray connects the light source (L) to S (the station point). The point of intersection on the picture plane gives us the vanishing point of the light source (VL).

The perpendicular of VL on HH creates the shadow vanishing point (VS).

Front Lighting. The light source is located in the back of the viewer. To construct the shadow, we need a projection of it. We extend a projection ray from L through S. The point of intersection at PP is again our VL (vanishing point of the light source). This time, VL is below the HH. VS is again found with a perpendicular.

Side Lighting. L is located exactly along the PP. All light rays, therefore, run parallel to it. Here, we only need to find out the angle of incidence to the horizon, α. The projection ray from L to the CVP creates it for us.

How the shadows fall in each case described here is shown by the cubes at the right.

. . . Please turn the page!

49

In order to better demonstrate the construction of shadows with front and back lighting, we will take the yellow box we used earlier and construct shadows on it.

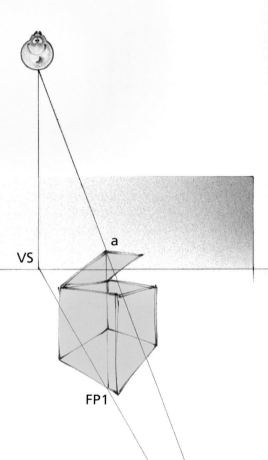

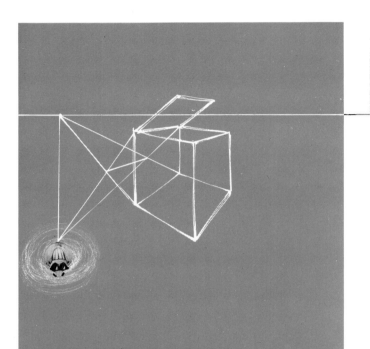

As already mentioned, the depiction of shadows with front lighting is created with a sun vanishing point below the horizon line. The larger the distance between the vanishing point of the light source (VL) and the shadow's vanishing point (VS), the shorter are the shadows that fall. The position of VL can be freely chosen.

Step 1. The most dramatic kind of shadow depiction is achieved with back lighting. We use our yellow box again. In addition, we will use the horizon and paint a VL (vanishing point of the light source) and a VS (vanishing point of the shadow). First, we construct the shadow endpoint that is farthest away from the object. It is the point of intersection of the straight line through VL and point a and through VS and the footpoint (FP1) of a. The shadow endpoint that is farthest away is usually created by the highest point of the object that cast the shadow.

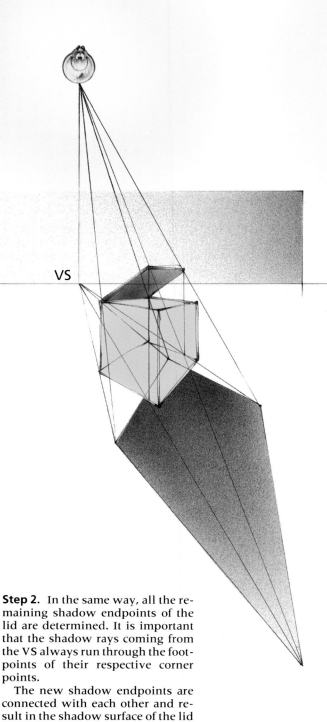

VS

Step 2. In the same way, all the remaining shadow endpoints of the lid are determined. It is important that the shadow rays coming from the VS always run through the footpoints of their respective corner points.

The new shadow endpoints are connected with each other and result in the shadow surface of the lid on the ground plane.

In our case, the underside of the lid lies in shadow.

The shadows of the edges have the same vanishing point or points as the edges themselves have.

Step 3. And so on. The remaining endpoints of the object also have their shadow endpoints. The two shadow surfaces are added together and filled with a nice progression of tone. The object surfaces on the shadow side need to be darkened somewhat, and the three-dimensional illustration is finished.

By the way, the ground shadows only have a connection to their objects when at least one corner point of the object touches the ground plane.

51

To demonstrate how shadows fall in the case of direct side lighting, we can again take our yellow box and let the sun hit it from the right side.

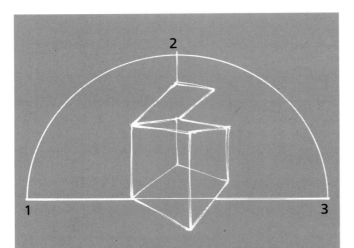

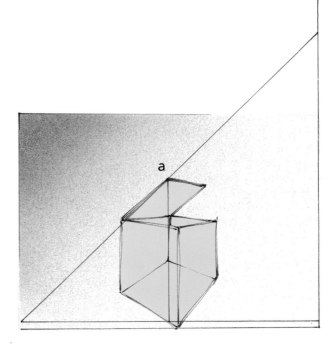

All the possibilities of light incidence with the sun shining directly along the picture plane are given above on the semicircular arch. In the case of the extreme values of 1 and 3, the light shines directly from the left or from the right. The sun's rays then run parallel to the shadow rays. There is no shadow endpoint.

If the light source is in Position 2, the light is coming directly from above. In this case, the shadow contours are identical with the contours of the respective objects or subjects. Objects such as our cube, which stand directly on GP, the ground plane, stand on their shadows in that case.

Step 1. Take an object, e.g., a yellow cube with a slightly opened lid, and a horizon line. Add a sun-beam running through the highest point of the object, and let it collide with the horizontal shadow ray that belongs to it.

This point of intersection is called the shadow endpoint of a. In side lighting construction, all shadow rays and sun rays run parallel to each other.

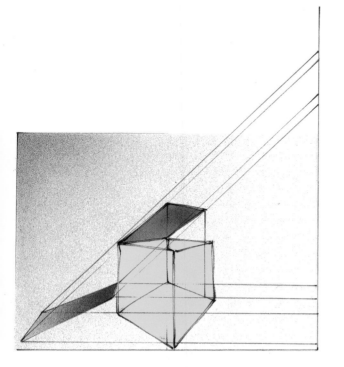

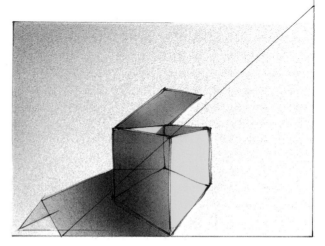

Step 2. Again, we first construct the shadow of the lid. We have one of the four points that we need for this. The remaining three are defined in the same way.

In the case of side lighting, the shadow rays always run parallel to HH (the horizon line) and through the VP of the individual corner points. But the sunbeams can also fall from another angle.

The individual shadow points remain to be connected into a surface and then we come to . . .

Step 3. Last but not least, the shadows of the box are added, so that it looks real. Again, we proceed step by step. The lid's shadow and the new cube shadow are added to one another, and the shadow construction is finished. The surfaces on the box that are turned away from the sun are darkened. Within the shadow surface, we create a believable diminution of brightness. Thus, the work is complete.

e. 30ml.

e.30ml.

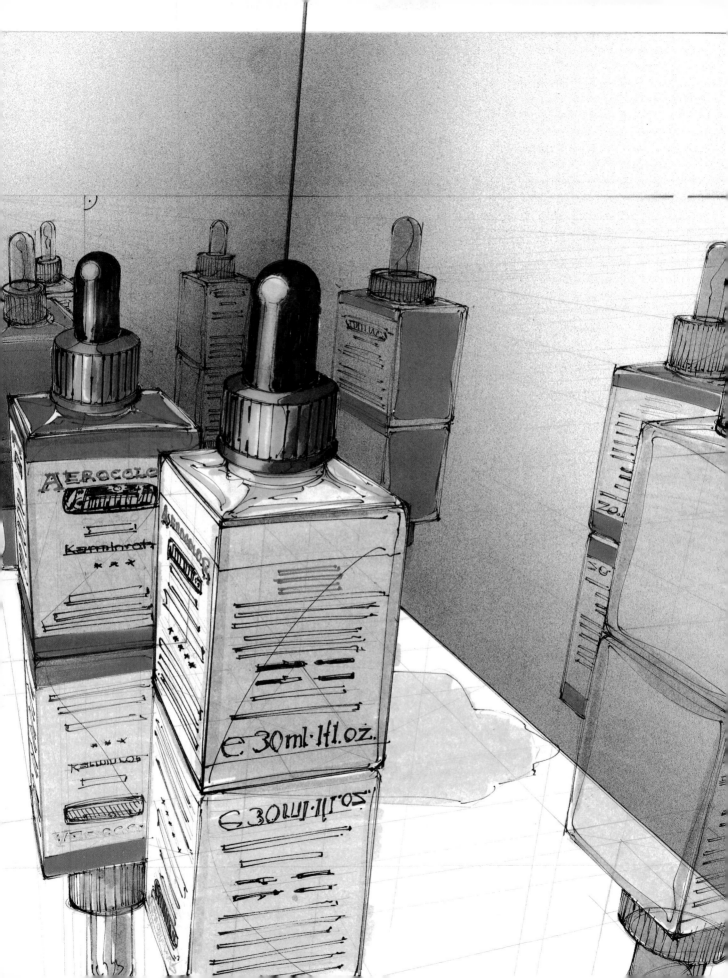

On the next four pages, we explore reflections. They adhere to simple rules, like those for the construction of objects and shadows.

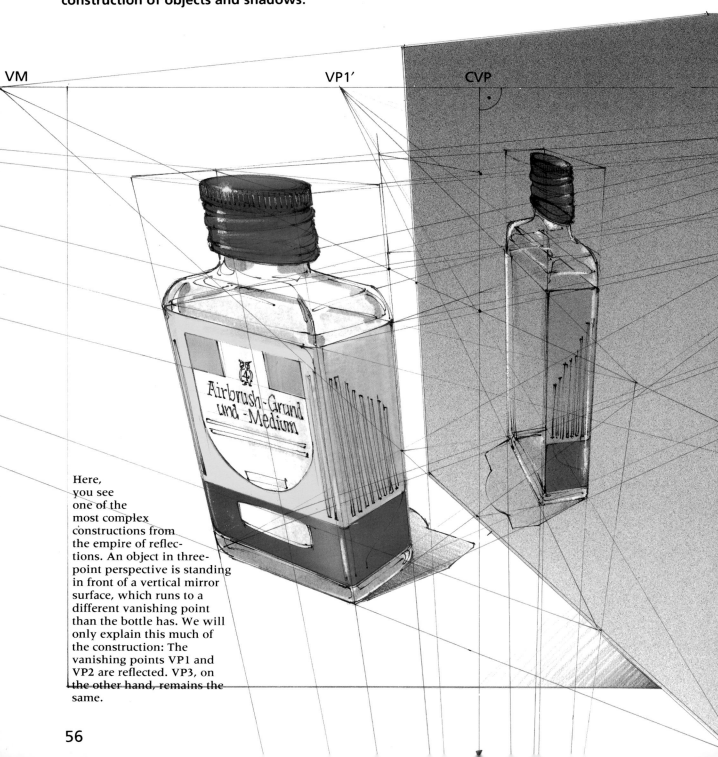

VM

VP1'

CVP

Here, you see one of the most complex constructions from the empire of reflections. An object in three-point perspective is standing in front of a vertical mirror surface, which runs to a different vanishing point than the bottle has. We will only explain this much of the construction: The vanishing points VP1 and VP2 are reflected. VP3, on the other hand, remains the same.

Airbrush-Grund und -Medium

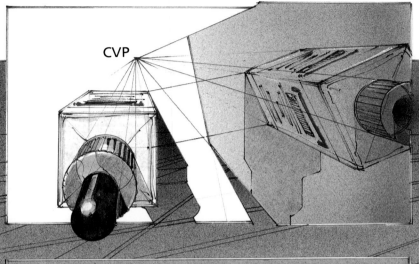

The familiar little bottle looks in the mirror at itself.

We construct the reflection by first drawing the perpendiculars from the corner points to the mirror surface and by adding on the same length again to these perpendiculars.

The depth edges of the little bottle, of the mirror, and of the reflection all end in CVP, the central vanishing point.

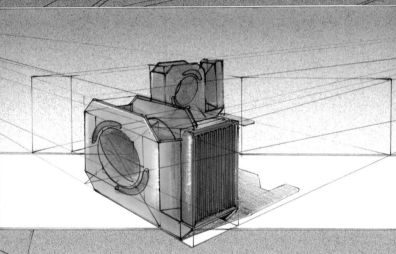

The mirror surface stands perpendicular to the ground plane and parallel to the horizon line. The tape dispenser stands in front of it at an angle. It is constructed in two-point perspective.

The ground surface of the dispenser is projected onto the mirror surface. From these, we draw vanishing lines to VP1 and VP2. The points of intersection result in the reflection.

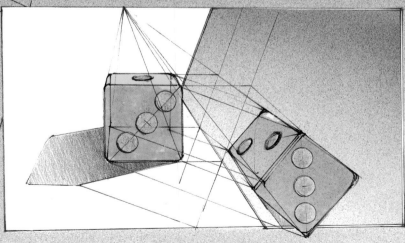

A vain cube stands in front of a tilted mirror. Again, all receding edges have a common vanishing point, including the reflection. The reflected cube is created in the familiar way. From all corner points of the original, perpendicular lines are projected onto the mirror plane and are duplicated.

To conclude the last construction chapter, I will demonstrate a few remarkable ways that reflections in the horizontal line behave.

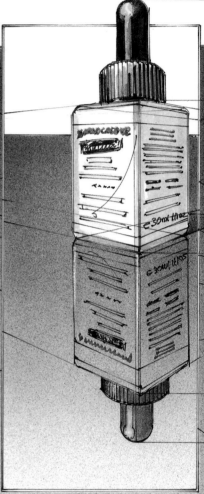

The little bottle stands on the mirrored ground plane.

This time, VP1 and VP2 remain completely unchanged. Only the verticals are true to scale when reflected downwards. To complete the reflection, only the receding edges and the screw-on cap remain to be drawn.

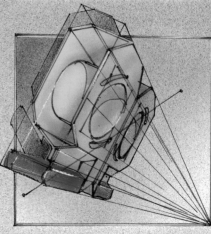

We see our familiar tape dispenser in the familiar overhead view with the familiar CVP on the familiar mirror surface.

We get the depth of the reflection from the point of intersection of the diagonals (see drawing).

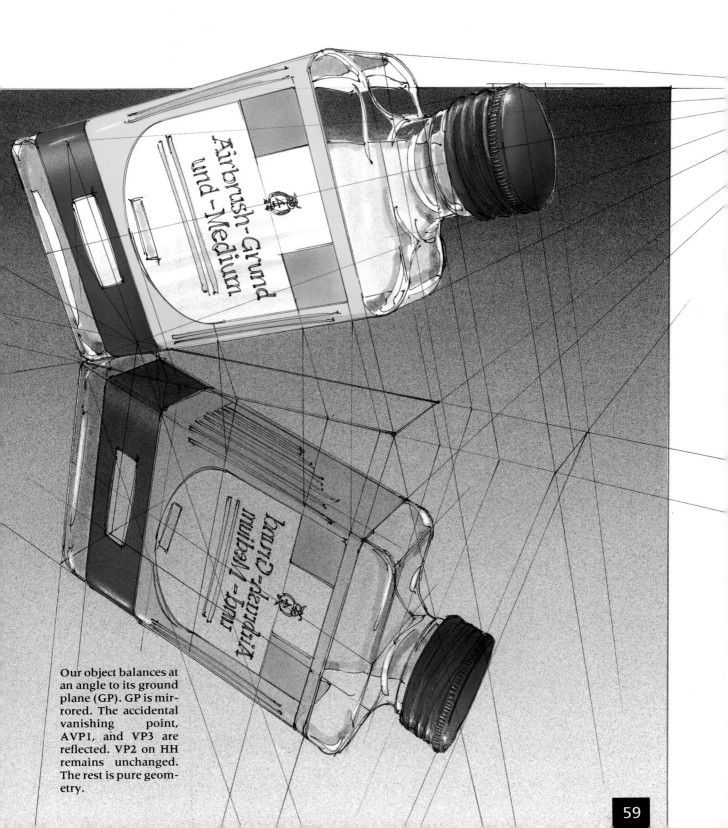

Our object balances at an angle to its ground plane (GP). GP is mirrored. The accidental vanishing point, AVP1, and VP3 are reflected. VP2 on HH remains unchanged. The rest is pure geometry.

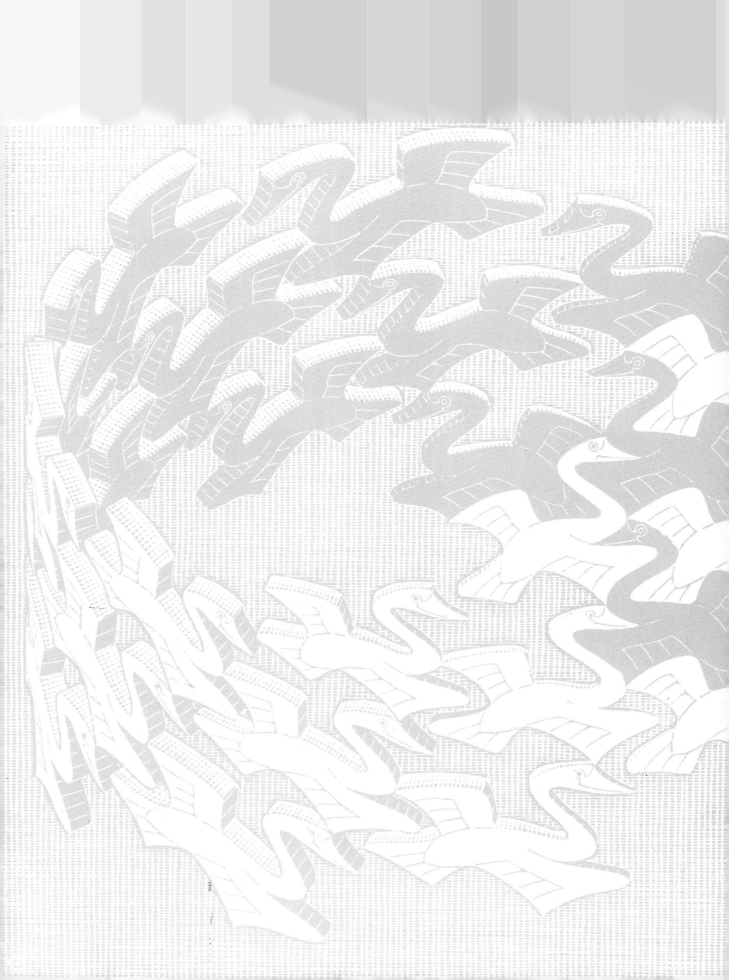

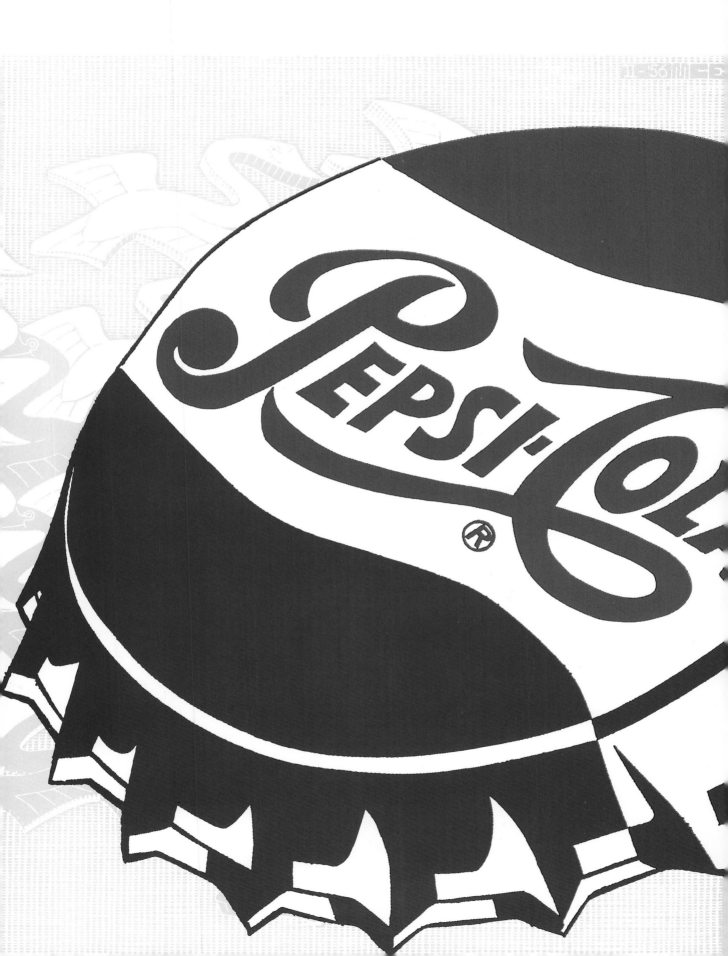

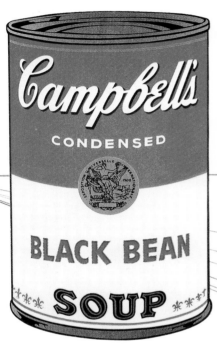

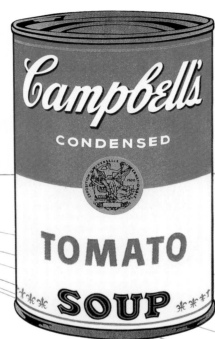

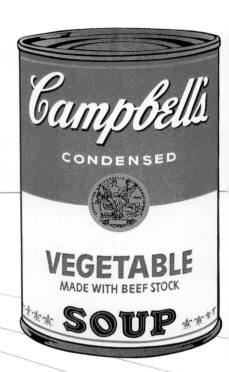

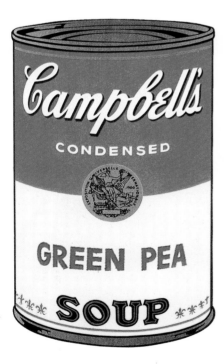

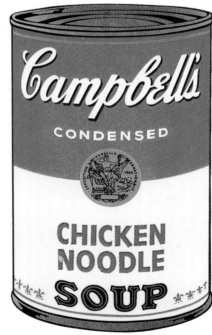

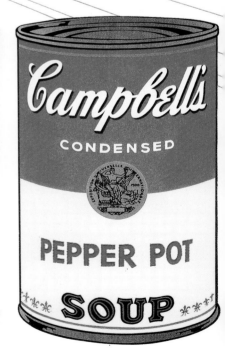

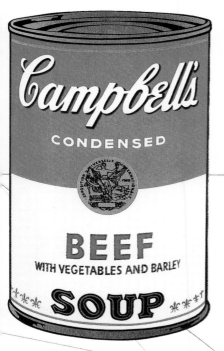

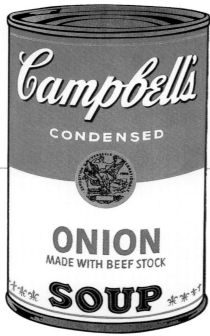

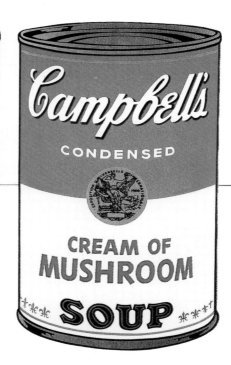

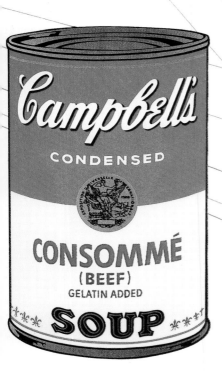

Without a doubt, we could get that impression, when we look at his famous Campbell's soup cans.

The ellipses partially taper off; the typography does not become narrower towards the edge and does not follow the curves. In addition, the shadows are missing, not to mention reflections. In the construction on the lower right, we come somewhat closer to the matter. Well, if Andy had only shown some interest in perspective! Nevertheless, the cans still rank today among the top ten in modern applied arts. We see that today it is possible to become famous, even without the knowledge of perspective. (The picture on the previous page shows a section of Warhol's piece *Close Cover before Striking* [*Pepsi Cola*] from 1962.)

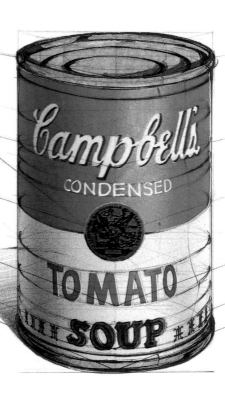

Mauritz Cornelis Escher (1889–1972) was a Dutch graphic designer who became very famous with his picture-puzzle landscapes and his brain-teasing book illustrations. His play with perspective created new, often irrational worlds.

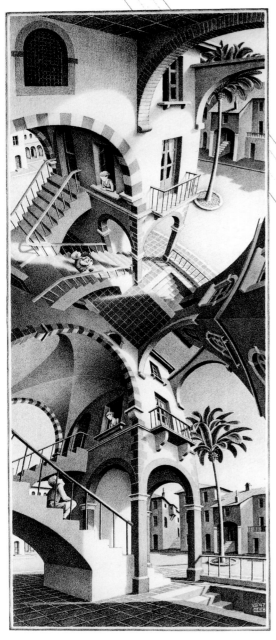

Above and below, lithograph from 1947.

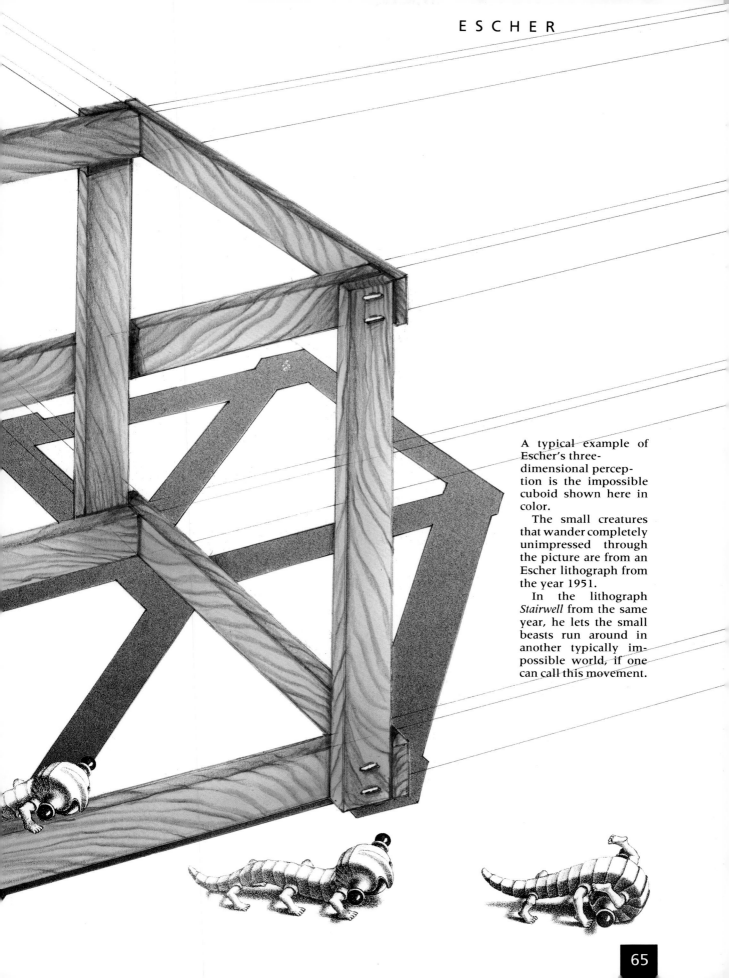

A typical example of Escher's three-dimensional perception is the impossible cuboid shown here in color.

The small creatures that wander completely unimpressed through the picture are from an Escher lithograph from the year 1951.

In the lithograph *Stairwell* from the same year, he lets the small beasts run around in another typically impossible world, if one can call this movement.

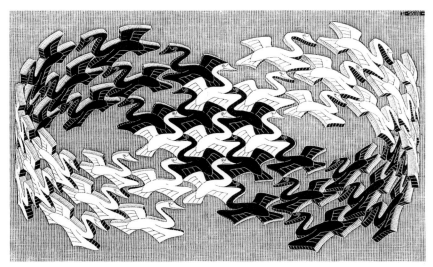

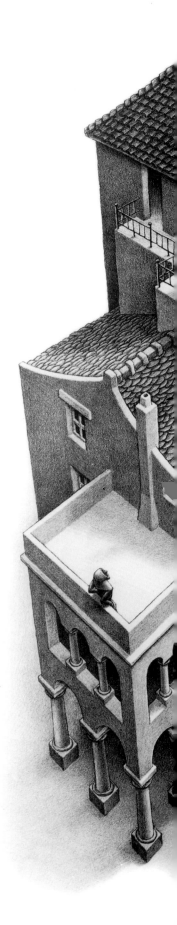

Above: *Swans*, a woodcut from 1956 (this was also the background of pages 60 and 61).
Below: *Tetrahedral Planetoid*, a woodcut from 1954.

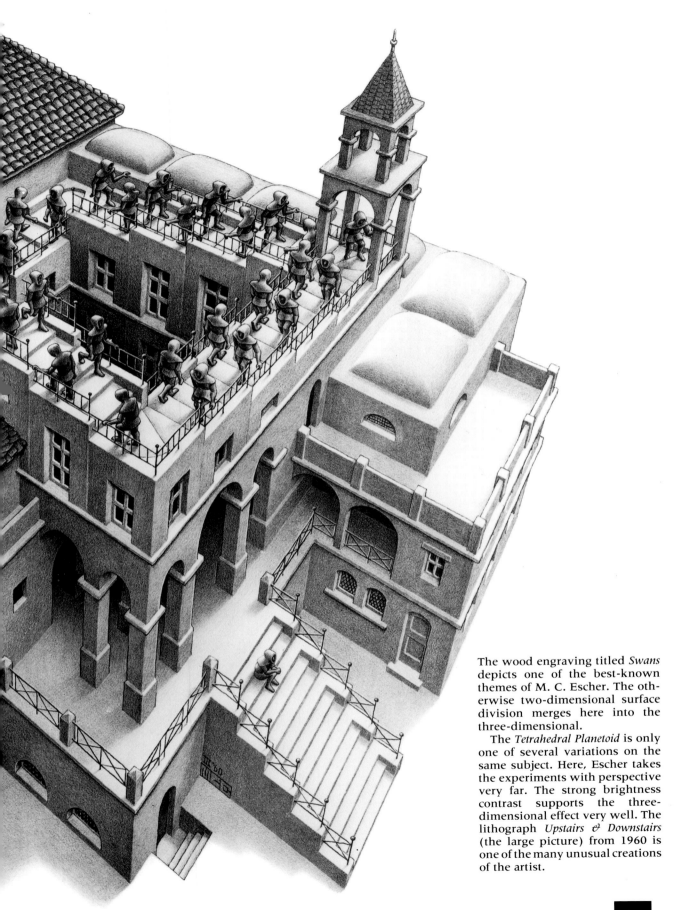

The wood engraving titled *Swans* depicts one of the best-known themes of M. C. Escher. The otherwise two-dimensional surface division merges here into the three-dimensional.

The *Tetrahedral Planetoid* is only one of several variations on the same subject. Here, Escher takes the experiments with perspective very far. The strong brightness contrast supports the three-dimensional effect very well. The lithograph *Upstairs & Downstairs* (the large picture) from 1960 is one of the many unusual creations of the artist.

With the help of modern electronic media, type also can be depicted three-dimensionally. Software producers continue to develop more and more complex programs for computerized type.

One possible perspective construction of typography without using a computer can be seen here. The letter is drawn on a grid, which then can be distorted. The letter is then reproduced box by box.

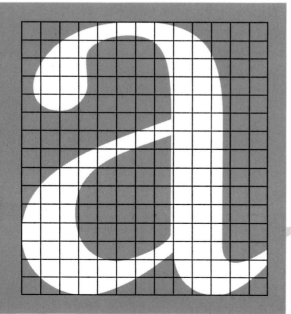

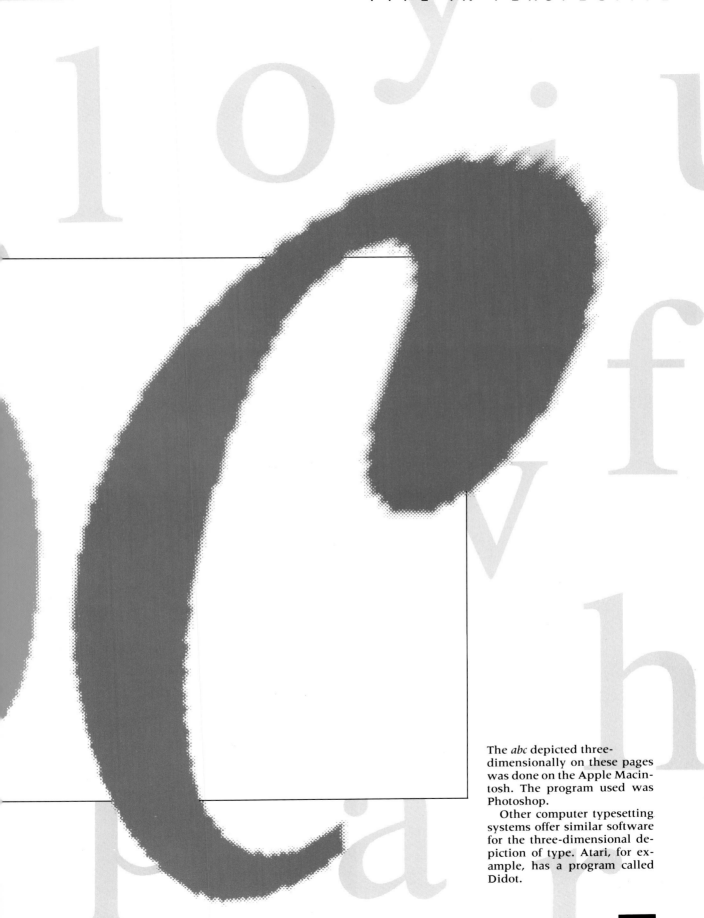

The *abc* depicted three-dimensionally on these pages was done on the Apple Macintosh. The program used was Photoshop.

Other computer typesetting systems offer similar software for the three-dimensional depiction of type. Atari, for example, has a program called Didot.

Using modern computer-assisted design (CAD) systems, complex objects can be created quickly and effectively.

The following example was created on a Hewlett Packard workstation with the CAD program Pytha.

Pytha is programmed in Basic and was about five years old in 1993. In the computer field, five years is half an eternity. The pro-gram calculates relatively slowly. New systems are becoming more and more efficient and rapid. But not too much has changed regard-ing the individual construction steps, so Pytha is sufficient for our demonstration.

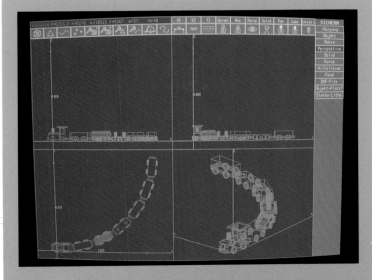

The "drawing paper" is the screen. The "pencil" is the mouse. The basic forms are mathematical functions, and the colors are mathematical processes. Our object is supposed to be a toy train. To do this, we begin with the construction of a grid model. The model is seen in the first three dimensions and in axonometric view.

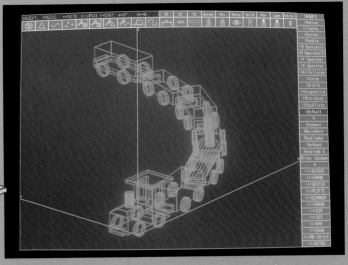

Each view can also be viewed separately. In the picture on the left, we see the axonometric view. Each complex object is put together with so-called *macros* (individual solids). Our toy is made completely of basic units.

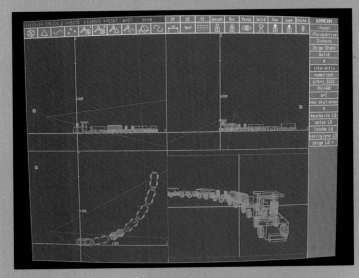

When the object's construction has been completed, the elements are taken over into the next program unit, "Perspective." And this one behaves as its name suggests.

The location of the viewer and the visual angle are determined. The location and the number of light sources are added, and the whole thing is done again in four views.

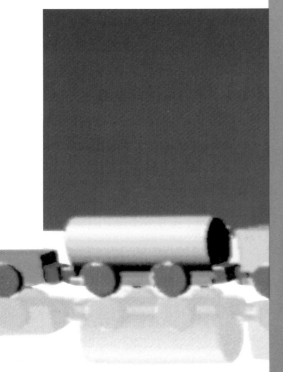

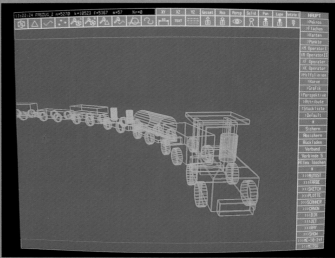

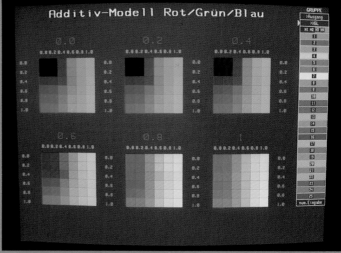

We see the grid model in the perspective view, as it will be later on in the completely finished graphic representation.

When the desired view has been achieved, and the light sources have been placed correctly, everything is stored. But before the final graphic representation can be processed, the surfaces still have to be defined. For that, the construction is taken from the Perspective part into the color data part.

In Pytha, there are two possibilities of color choice, for the objects and the background. Here, the red–green–blue model is pictured, which is based on the basic colors of the color screen.

The second color model is based on brightness and color saturation. Several color groups are covered. We chose really basic colors: red, yellow, and blue, plus white.

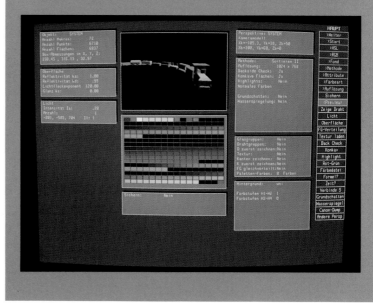

The surfaces of the train are covered with the previously chosen color groups. In the background, we insert a vertical color run above the previously defined table edge. Then we activate the water reflection and wait for the Preview. We wait. If we do not like the preview, we eliminate the reasons for our dislike through new inputs. If we like the preview, we start the final calculation process, and we wait for the finalized graphic representation.

Rot = red; *Grün* = green; *Blau* = blue—Ed.

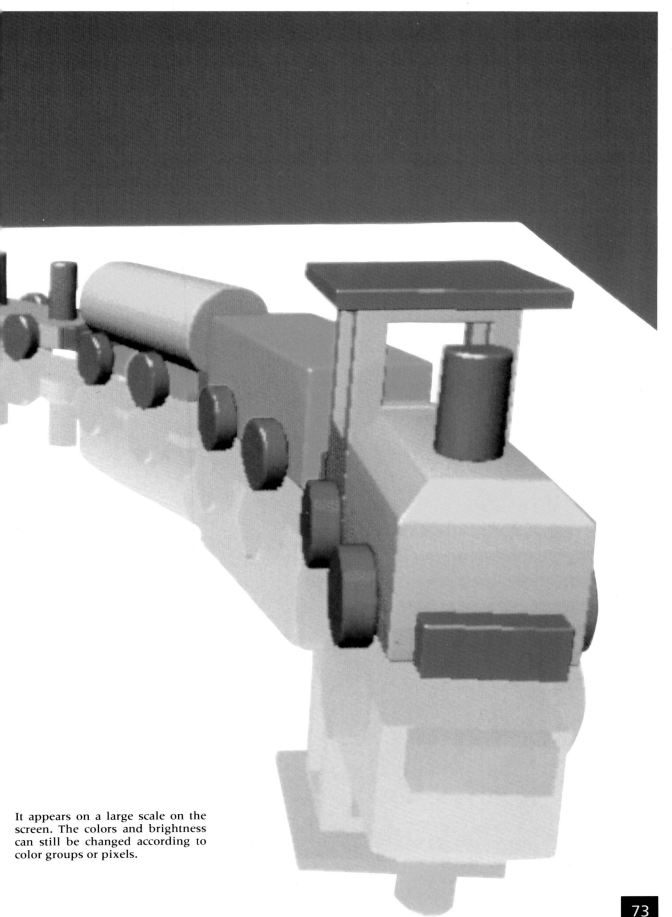

It appears on a large scale on the screen. The colors and brightness can still be changed according to color groups or pixels.

Finally we come to the subject of stereo pictures. Stereo viewing is similar to hearing; two dimensions create three dimensions. We simulate this on the paper with the colors red and green.

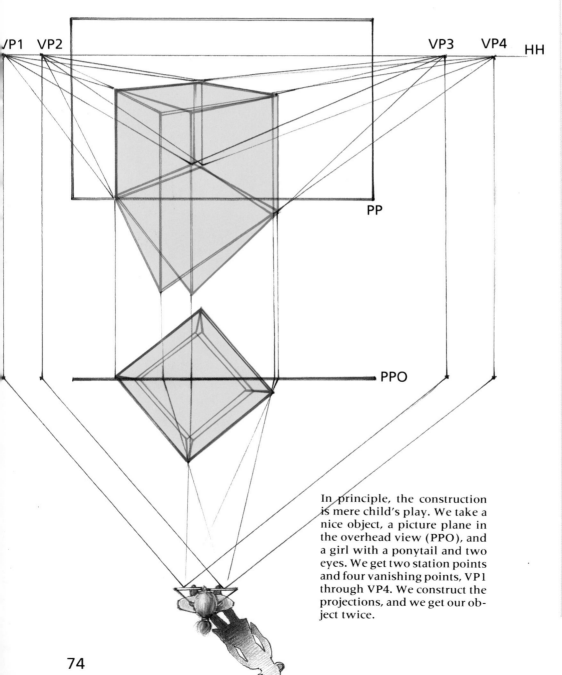

In principle, the construction is mere child's play. We take a nice object, a picture plane in the overhead view (PPO), and a girl with a ponytail and two eyes. We get two station points and four vanishing points, VP1 through VP4. We construct the projections, and we get our object twice.

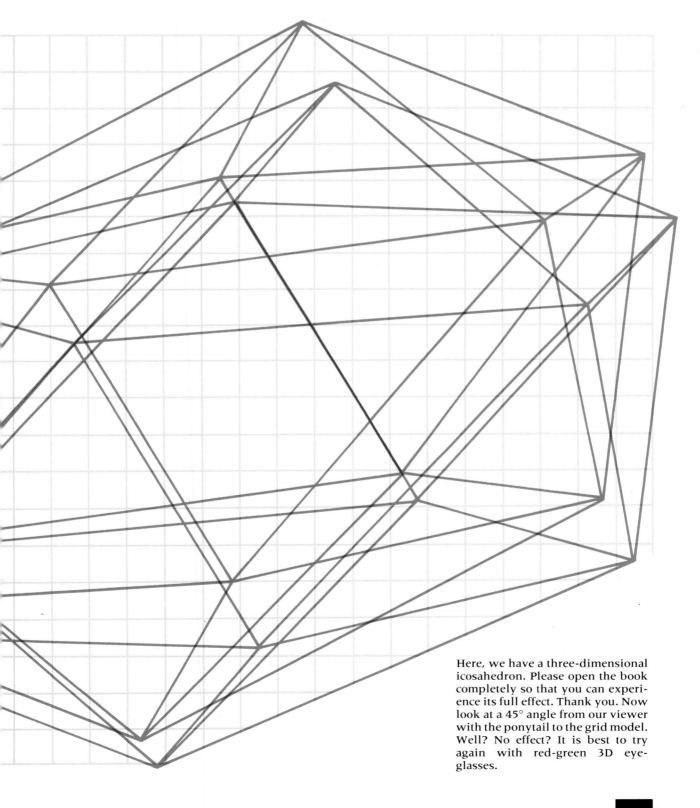

Here, we have a three-dimensional icosahedron. Please open the book completely so that you can experience its full effect. Thank you. Now look at a 45° angle from our viewer with the ponytail to the grid model. Well? No effect? It is best to try again with red-green 3D eyeglasses.

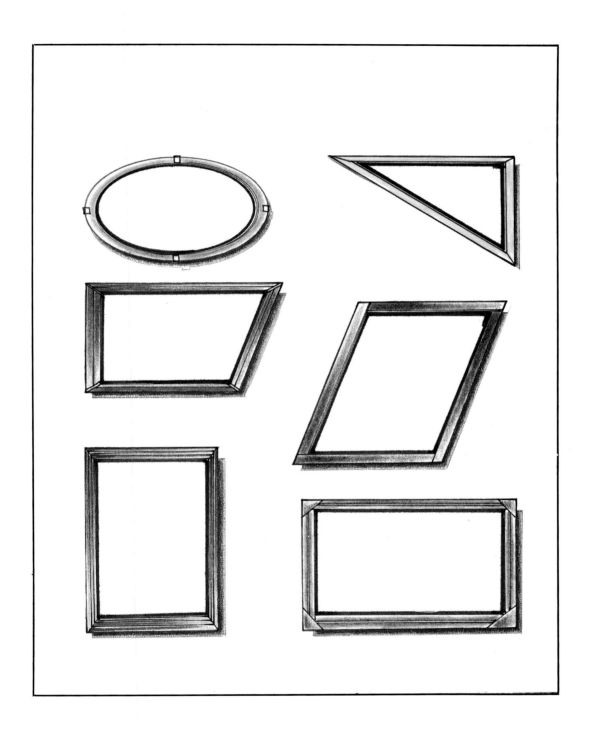

Trace the viewfinder template given above onto stiff paper or cardboard, and cut it out of the cardboard. Then cut out the geometric shapes inside the frames. Paint the template. You can use the viewfinder to plan drawings.

This is the end. But only the end of this book. Thank you, everyone, for your attention. And always keep in mind: Perspective is purely a point of view.